TWO
CENTURIES
OF

SHADOW CATCHERS

History
of Photography

TWO CENTURIES OF

SHADOW CATCHERS

History of Photography

RONALD P. LOVELL
FRED C. ZWAHLEN, JR.
JAMES A. FOLTS

Delmar
Publishers Inc.

I(T)P™ *An International Thomson Publishing Company*

New York • London • Bonn • Detroit • Madrid • Melbourne • Mexico City • Paris
Singapore • Tokyo • Toronto • Washington • Albany NY • Belmont CA • Cincinnati OH

FOR MORE INFORMATION,
CONTACT:

Delmar Publishers Inc.
3 Columbia Circle Drive, Box 15015
Albany, New York 12203-5015

International Thomson Publishing
Berkshire House
168-173 High Holborn
London, WC1V7AA
England

International Thomson Publishing
Konigswinterer Str. 418
53227 Bonn
Germany

Thomas Nelson Australia
102 Dodds Street
South Melbourne 3205
Victoria, Australia

International Thomson Publishing
Asia
221 Henderson Bldg. #05-10
Singapore 0315

Nelson Canada
1120 Birchmont Road
Scarborough, Ontario
M1K 5G4, Canada

International Thomson Publishing
Japan
Kyowa Building, 3F
2-2-1 Hirakawa-cho
Chiyoda-ku, Tokyo 102
Japan

DELMAR STAFF:
Publisher: Mike McDermott
Administrative Editor: John Anderson
Project Editor: Barbara Riedell
Production Coordinator: Larry Main
Art/Design Coordinator: Lisa Bower

TEXT DESIGN:
Liz Kingslien

COVER DESIGN:
Bob Clancy/Spiral Design

COVER PHOTO COURTESY OF:
Edward S. Curtis Reproductions. Published with permission.

Library of Congress Cataloging-in-Publication Data:

Lovell, Ronald P.

Two centuries of shadow catchers: history of photography / Ronald P. Lovell, Fred C. Zwahlen, Jr., James A. Folts.
 p. cm.

Includes bibliographical references and index.
ISBN 0-8273-6457-1

1. Photography—History—19th century. 2. Photography—History—20th century. I. Zwahlen, Fred C., 1924- . II. Folts, James A. III. Title.

TR15.L68 1994
770'.9—dc20 94-8518
 CIP

PREFACE

This was a complicated book to write. In fact, writing was only half the task we faced in bringing the story of photography to these pages. Locating and gathering the more than 100 photos was equal parts detective work and perseverance. Our success in this endeavor is due in large part to the help we received from staff members at a number of photo archives and museums. We thank them—and the owners and donors of individual photographs—for this assistance. As always, our wonderful friend Chris Johns contributed a number of his magnificent photos. We thank him for that.

We express our gratitude as well to Delmar editors Mike McDermott, Vern Anthony, and, most especially, John Anderson, who went above and beyond the normal duties of an administrative editor. We also wish to thank others at Delmar: Barbara Riedell, project editor; Larry Main, production coordinator; Lisa Bower, art/design coordinator; Anne Harding, freelance copy editor; and Helen Kinsella, proofreader. Liz Kingslien, our designer, gave the book its distinctive look. The words and photos on these pages would be rather lifeless without her special touch, for which we thank her, along with Amy Charron, who did the illustrations in Chapter 13. We also thank our intrepid typist, Treena Martin.

We appreciate the comments of our reviewers: Jerry Hoffman, Tucson High School, Arizona; Daniel Dantonic, Downington Senior High School in Pennsylvania; Ling-Hsiao Lee, Central Michigan University; and Bryan LaFollette, Vincennes University in Indiana.

In the end, of course, this book would not have been possible without the lifelong work of a remarkable group of men and women who devoted their lives to their profession. These "shadow catchers" overcame great technical obstacles to perfect an art form that has given pleasure to millions of people over the years. Their collective ability to capture haunting images in the camera's lens has enriched our culture and our souls.

Ron Lovell
Fred Zwahlen
Jim Folts

TABLE OF CONTENTS

CHAPTER 1

THE DAWN OF PHOTOGRAPHY

Camera obscura means dark room in

Latin . . . an opening at one end to

let light in; the light falling on the

opposite wall to form an image. . . .

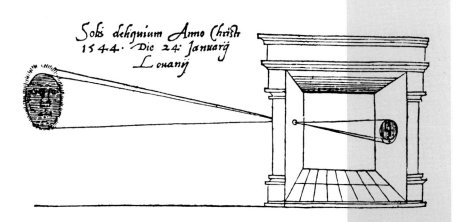

Solis deliquium Anno Christi
1544. Die 24: Januarij
Louanij

THE DAWN OF PHOTOGRAPHY

T he desire to reproduce images in multiple copies began long before photographic technique—or even the word to describe it—came into existence.

PRIMITIVE BEGINNINGS TO HELP PAINTERS

The camera obscura—"dark room" in Latin—was the forerunner of the modern camera. It was a room with a single opening in one wall that projected an inverted image of the scene outdoors on the opposite wall (Figure 1.1). Although known for centuries, this device was not put into general use until it was described by Italian scientist Giovanni Battista della Porta in his popular 1544 book, *Natural Magic*. The book

FIGURE 1.1
THE CAMERA OBSCURA, 1544
[Courtesy of the Gernsheim Collection, Harry Ransom Humanities Research Center, The University of Texas at Austin]

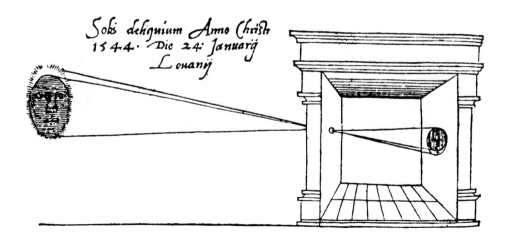

was widely read, and its content—including the description of the camera obscura—became well known. Whole buildings soon were being built as camera obscuras. They became tourist attractions.

To be more practical and portable, the room became a box. The importance of the camera obscura was not in its size but in its characteristics: an opening at one end to let light fall on the opposite wall to form an image, usually on a white paper or white cloth screen, and a concave mirror set up opposite the opening to receive the image.

Artists used camera obscuras in box form for tracing outdoor scenes. The device helped even unskilled artists. The device also was useful for Renaissance artists, who used it to achieve correct perspective.

Inventors sought to perfect variations on the camera obscura. One was the camera lucida, invented by William Hyde Wolleston in 1807. In it a prism and lens were arranged on a stand in such a way that a draftsman could see a distant object superimposed on the drawing paper.

Artists of the sixteenth, seventeenth, and eighteenth centuries also were aided by the invention of a series of drawing machines, described as tools to facilitate the work of artists by increasing accuracy and precision. Thomas Allason's 1816 "perspectograph" was one such well-known device. It consisted of a 9 inch x 6 inch metal frame with two graduated scales moving on its surface, one perpendicular to the other, in order to find both the horizontal and vertical distances. Both directions were measured off by metal rods that would be raised or lowered, lengthened or shortened depending on what was being drawn.

While early drawing machines were used primarily for mechanical and scientific purposes, they came into use in the late eighteenth century as a way to produce quick and inexpensive portraits. They were especially popular for silhouettes and profiles. In later derivatives of this technique, an artist actually placed the subject in a frame so that part of the machine touched his or her face and guided the artist in making a direct life-size tracing of the profile.

By the seventeenth century, a lens had been placed in the hole to improve the image and the camera obscura was made smaller and more portable—first a small hut, then a sedan chair, next a small tent; and eventually a portable box.

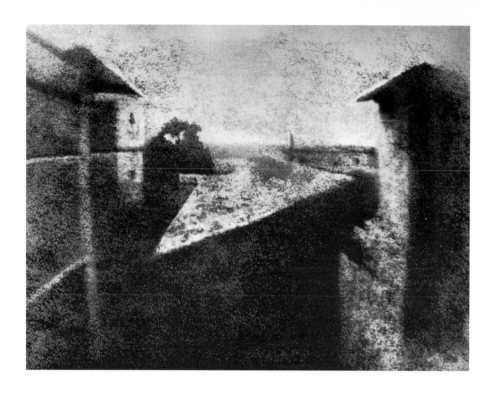

Inventors were working on other developments that eventually led to the photographic process. In 1727, Johann Heinrich Schulze discovered that light darkened a solution of silver nitrate. In 1802, Sir Humphry Davy and Thomas Wedgwood soaked paper and leather in silver nitrate, laid objects on the sensitized surface, and exposed the arrangement to sunlight. This method produced silhouettes that were later called photograms.

Wedgwood's goal was to fix the images of the camera obscura, which were often too faint to produce "in any moderate time, an effect upon nitrate of silver." He did not succeed, and died three years later at 34. Davy carried on the chemist's work but also failed to achieve Wedgewood's goals.

Although called by some historians the "discoverer of photography," Wedgwood never fixed images on paper.

THE FIRST PHOTOGRAPH

That achievement belongs to Joseph Niepce, a French physicist, who worked most of his life on the family estate

near Chalon. In 1816, he made a negative image in which dark and light were reversed by placing a piece of paper sensitized with silver chloride in a camera. Niepce was unhappy that the image was not permanent and that it was a negative. In 1822, he found a way to produce a positive copy of an engraving by exposing a glass plate coated with an asphalt-like substance. He called the process heliography. His first successful and permanent heliographic print was of an engraving of Pope Pius VII.

The process worked this way: the asphalt (called bitumen of Judea) was dissolved in oil of lavender and a thin layer was spread on a glass plate, on which was superimposed an engraving made transparent by oiling. After the bitumen was exposed to light for two or three hours, it became hard under the white parts of the engraving. The area under the dark lines remained soluble and could be washed away with a solvent made of oil of lavender and turpentine.

Niepce copied several engravings in a similar way over the next few years with one difference: he now used metal instead of glass. He continued working to perfect the technique so it could be used to make positive pictures in a camera.

He finally succeeded in 1826 when he recorded the view from his second floor window (Figure 1.2). The view was similar to the one he had earlier described to his brother, Claude, in an 1816 letter: to the left the pigeon house, to the right of it a pear tree with a patch of sky showing through its branches, in the center the slanting roof of the barn; behind that the bakehouse and on the right a wing of the house.

The image is primitive by today's standards, showing only the outlines of buildings and the tree and very little detail. But it is the world's first photograph—the first permanent image made with a camera. Niepce's "film" was a piece of pewter coated with the same asphalt-like substance used in his earlier experiments. The exposure time was about eight hours, ten million times as long as modern films require.

In 1829, Niepce formed a partnership with Louis Jacques Daguerre, a Paris painter. The two aimed to improve heliography. Daguerre began experimenting with silver, despite his new partner's misgivings about its potential for producing a positive image. His tireless efforts would lead to the next important milestone in the history of photography.

THE DAGUERREOTYPE

*M. Daguerre has discovered a method to fix the images
which are represented at the back of a camera obscura; so
that these images are not the temporary reflection of
objects, but their fixed and durable impress, which may
be removed from the presence of those objects like a pic-
ture on an engraving....*

This item in the January 6, 1839 issue of the Paris
newspaper *Gazette de France* heralded an important discovery.
Quite by accident, Daguerre had found that he could produce
a permanent positive image by sensitizing a silver-plated
metal sheet with iodine fumes, exposing it to light, develop-
ing it over mercury fumes, and then fixing the image in a
concentrated salt solution.

It was ironic that Daguerre would be responsible for
this significant development. His rather checkered career had

taken him in many directions, none of them scientific. The son of a low-ranking clerk, Daguerre had little formal education. He worked first as a stage designer, then had moderate success as a painter. He formed the partnership with Niepce after the latter had failed to get the Royal Society in London to recognize heliography.

Niepce took Daguerre on after he pledged to improve the invention and make it more practical. But Niepce died in 1833 without seeing his invention improve. His 25-year quest to succeed as the inventor of the heliography process was so unsuccessful that his widow was forced to sell his estate to have enough money to survive.

Daguerre carried on with Niepce's work and presented his first successful picture, a still life taken in his studio, to the director of the Louvre Museum. He had hoped to bring the process to the attention of artists. His ploy did not work.

As a result, Daguerre decided to commercialize what he started calling "daguerreotypes" by selling 200 licenses at one thousand francs each. He publicized his venture by driving around Paris on a cart with the image-capturing apparatus mounted on its back. By photographing public buildings and showing the result fairly quickly, he hoped to attract the necessary public attention and capital (Figure 1.3). The venture failed apparently because the public was put off by the rather mysterious—and gaseous—process before them. No one bought a license.

In desperation, Daguerre turned to scientists and other artists for help in overcoming public skepticism. He had soon gained a powerful ally in Francois Arago, secretary of the Academy of Sciences and deputy leader of the Republican opposition in the Chamber of Deputies. Arago realized the importance of the discovery and soon was proposing that the French government purchase the invention to safeguard its future. With the assistance of other scientists, Arago proposed a bill granting life pensions to Daguerre and Isidore Niepce, his partner's widow.

Arago kept promoting the invention. He said that the daguerreotype would enable anyone to take a picture of a landscape in twenty to thirty minutes that was more accurate than an artist's drawing. This remark generated so much interest that Daguerre's instruction booklet had gone through thirty editions in eight languages by the end of the year.

When Daguerre began demonstrating his new process, the public no longer ignored it as they had the earlier cart-mounted version. These sessions showed that he could produce detailed positive miniature images and that people were interested. They were eager to learn about the new process and buy the pictures.

Because of the long exposure time required, Daguerre's process first was used for landscapes, architecture, and other inanimate subjects. In "Paris Boulevard," Daguerre took the first photograph of a human being (Figure 1.4): a man having his boots shined (Figure 1.5). After American scientist John Draper was able to make a daguerreotype portrait in 1859 using a half-hour exposure, however, he and inventor Samuel F. B. Morse promoted daguerreotype portraits in the United States. Before long, daguerreotype studios were

FIGURE 1.4
"PARIS BOULEVARD" BY LOUIS JACQUES DAGUERRE, 1839 [DAGUERREOTYPE] *[International Museum of Photography at George Eastman House. Published with permission]*

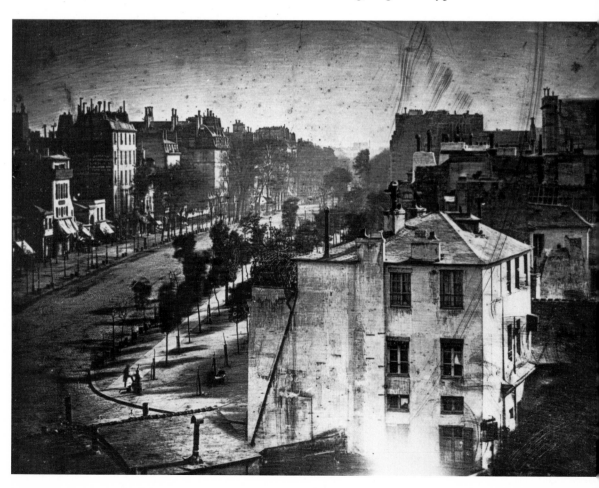

opening in nearly every sizable town and city around the country.

Portrait photography using the daguerreotype process quickly became extremely popular in both the United States and Europe, even though very early portraiture bordered on the cruel. It required the subject to sit still and to stare unblinkingly into the direct sun. A special clamp held the person's head tightly to keep it from moving. This probably accounts for the pinched expressions on the faces of most portrait subjects of the day. Few are smiling.

For the next twenty years, the daguerreotype process was the most practical method for producing photographs. The process spread around the world. From 1839 to 1860, an estimated 30 million daguerreotypes were made in the United States alone, of important people (Figure 1.6), news events (Figure 1.7), industrial activities like ship building (Figure 1.8), portraits (Figures 1.9 and 1.10), and public buildings (Figure 1.11).

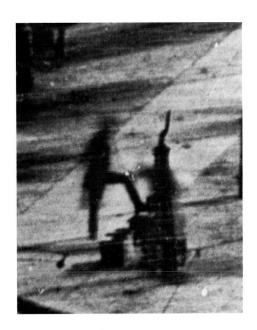

FIGURE 1.5
CLOSEUP OF A MAN HAVING
HIS BOOTS SHINED
(FROM "PARIS BOULEVARD")

This success came in spite of the drawbacks to the process: 1) long exposure time; 2) a mechanically fragile image; 3) an image that was not in color, but appeared in gradated tones.

Daguerre himself only produced eighteen images that survived. He bought a small property near Paris and worked to improve his process. In 1841, he announced that he had perfected a method to allow instantaneous pictures of public ceremonies, battles, or other news events. After an initial flurry of excitement, the claim proved to be exaggerated.

Daguerre died suddenly of a heart attack on July 10, 1851, without ever making the comeback he sought.

WILLIAM HENRY FOX TALBOT AND THE CALOTYPE

William Henry Fox Talbot has been called the third father of photography for his perfection of something that eluded both Niepce and Daguerre: turning a negative into a positive in a reasonably short period of time.

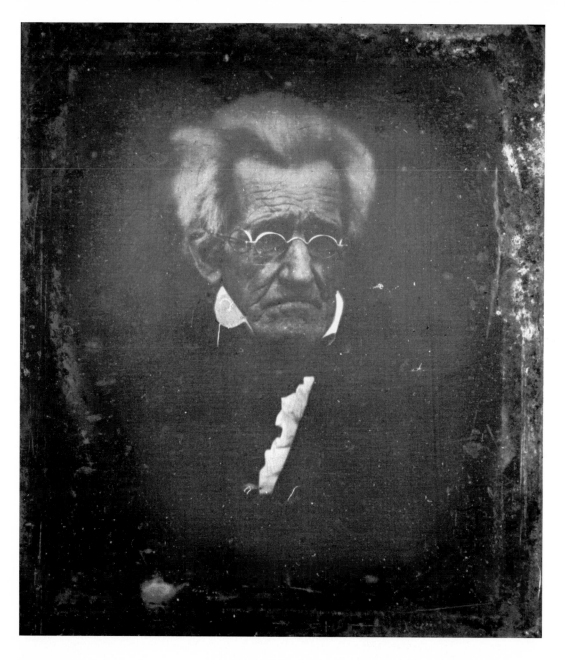

FIGURE 1.6
ANDREW JACKSON, SEVENTH
PRESIDENT OF THE UNITED
STATES, BEFORE 1845
[DAGUERREOTYPE] *[International
Museum of Photography at George East-
man House. Published with permission]*

Born in England in 1820 into a wealthy family, Tal-
bot was educated at Harrow and Trinity College, Cambridge.
After graduation, he returned to the family estate and began
to study mathematics and conduct scientific experiments on
the color spectrum.

On a trip to Lake Como in Italy in 1833, Talbot realized that his inadequate drawing skills were hampering his ability to capture images. He decided to try to produce images recorded by light itself that would be perfect reproductions of what he had seen in his camera lucida, a kind of portable camera obscura. In it, a prism and lens mounted on a stand allow the user to view a distant object superimposed on drawing paper, as noted earlier. This made copying easier. He decided to try using silver nitrate, but discovered that papers prepared with silver nitrate were not very light sensitive. As a result, he switched to silver chloride paper. His experimentation also led him to see that he could stop the action of light on the sensitive papers by soaking them in a strong salt solution.

FIGURE 1.7
FIRE AT AMES FLOUR MILLS,
OSWEGO, NEW YORK
BY GEORGE BARNARD, 1853
[DAGUERREOTYPE] [International
Museum of Photography at George East-
man House. Published with permission]

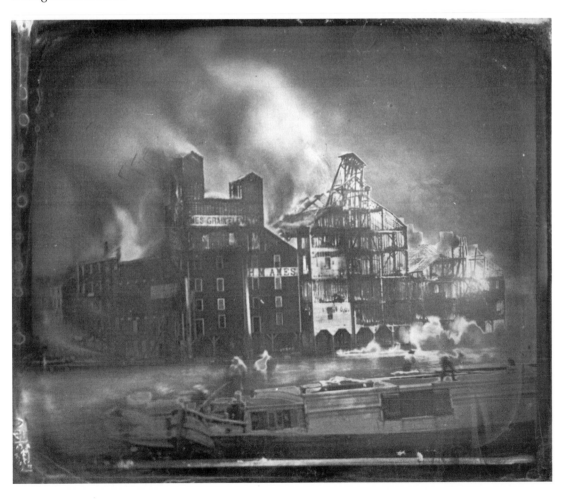

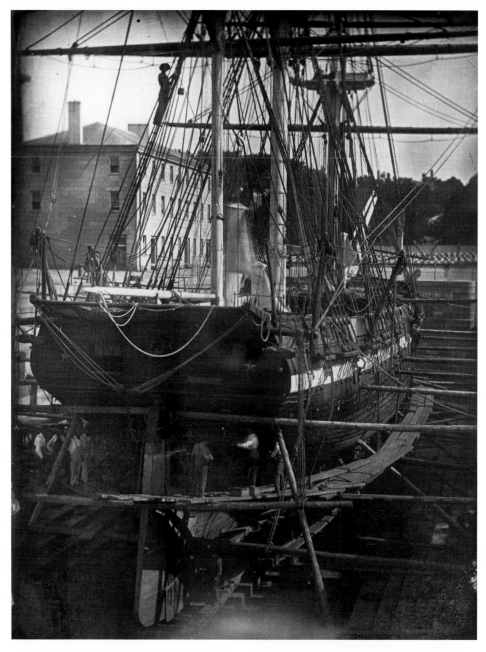

FIGURE 1.8
SHIP IN DRYDOCK IN BOSTON
HARBOR BY SOUTHWORTH AND
HAWES, 1852 [DAGUERREOTYPE]
[International Museum of Photography
at George Eastman House. Published
with permission]

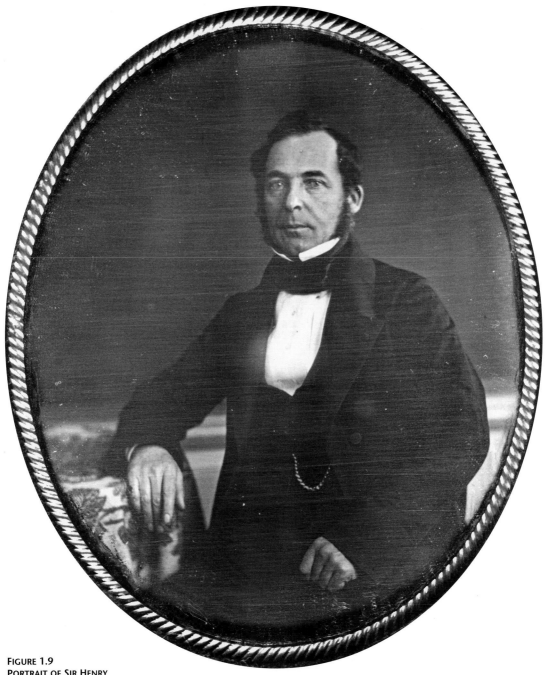

FIGURE 1.9
PORTRAIT OF SIR HENRY
BESSEMER, THE INVENTOR
OF STEEL, 1845 [DAGUERREOTYPE]
*[Courtesy of the Gernsheim Collection,
Harry Ransom Humanities Research Cen-
ter, The University of Texas at Austin]*

THE DAWN OF PHOTOGRAPHY

In the summer of 1833, Talbot made images of his house using the sensitive paper and a camera obscura, with exposure times of several hours. He did not publicize his success, however, and kept trying to perfect his discovery.

But after Daguerre and Arago published results of their daguerreotype work Talbot decided to go public to establish claim to his discovery. In January 1839, he prepared an exhibit of some of his images at the library of the Royal Institution (Figure 1.12).

Although agreeing that the work of Niepce and Daguerre took precedence over his own, Talbot did publish an account of his methods later that year. The British government did not acknowledge the importance of his work, however, as the French government had Niepce and Daguerre's. Talbot eventually patented his process.

FIGURE 1.10
COLLECTION OF BUTTERFLIES,
1850 [DAGUERREOTYPE]
[International Museum of Photography at George Eastman House. Published with permission]

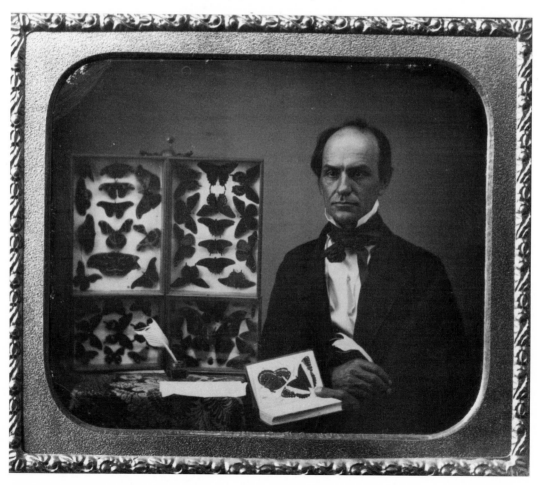

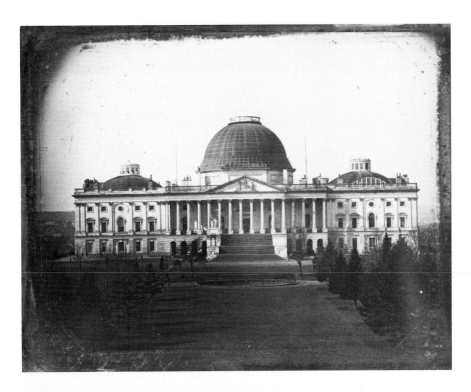

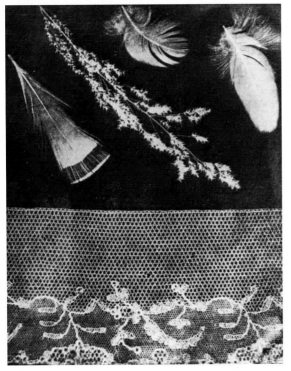

FIGURE 1.11
CAPITOL BUILDING,
WASHINGTON, D.C.
BY JOHN PLUMBE, 1845-1846
[DAGUERREOTYPE] *[Courtesy
of the Library of Congress]*

FIGURE 1.12
"MUSLIN AND FEATHERS" BY
WILLIAM HENRY FOX TALBOT,
1839 [CALOTYPE] *[Courtesy of the
Gernsheim Collection, Harry Ransom
Humanities Research Center, The
University of Texas at Austin]*

Talbot called his process the calotype. In simple terms, the technique worked this way: he produced a positive image from a negative by waxing the paper negative to make it translucent, sandwiching it with another light-sensitized paper, and then exposing the sandwich to light. The process allowed him to make multiple copies of a positive image from a single negative.

Although Talbot's calotype images did not match daguerreotypes in quality or popularity, the results were often interesting and unusual (Figure 1.13).

More importantly, Talbot worked out the outlines of photography as it is known today: a negative-positive process based on the light-sensitive properties of silver salts.

Talbot continued to experiment for the rest of his life, gaining a number of honors for his earlier discovery, but he did no practical photography after 1851. He died in 1877.

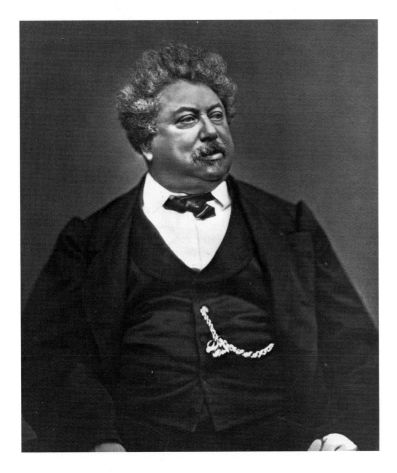

FIGURE 1.14
ALEXANDRE DUMAS BY CARJAT, 1878 [WOODBURYTYPE]
[International Museum of Photography at George Eastman House. Published with permission]

FIGURE 1.15
GEORGE SAND BY PAUL NADER,
1877 [WOODBURYTYPE] *[Interna-*
tional Museum of Photography at
George Eastman House. Published with
permission]

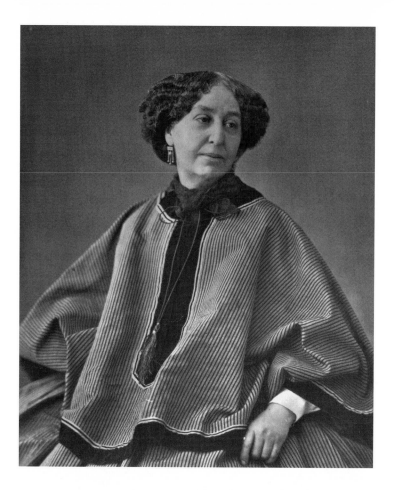

At the same time that Talbot was working on his exper-
iments, the English astronomer Sir John Herschel also was
experimenting with photography. He is credited with the dis-
covery of hyposulfite of soda (known today as fixer) as an effec-
tive chemical for fixing, or making permanent, a silver image.

As the nineteenth century entered its final twenty-five
years, photographic portraits had reached the point where
they rivaled their counterparts in oil (Figures 1.14 and 1.15).

CHAPTER 2

PHOTOGRAPHY AS ART

. . . The nude was among the first subjects of these new photos as art. . . .

Painters also began to use camera studies of nudes as first draft views of

scenes they would later paint. . . .

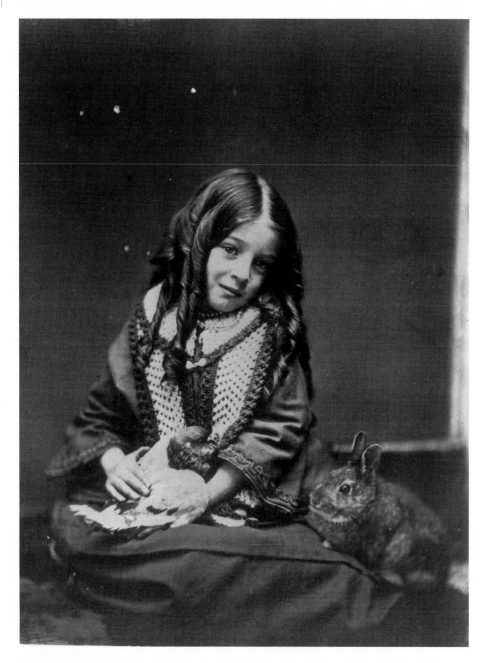

FIGURE 2.1
"THREE PETS" BY ALEXANDER
HESLER, 1851 [CRYSTALOTYPE
FROM ORIGINAL DAGUERREOTYPE]
*[International Museum of Photography
at George Eastman House. Published
with permission]*

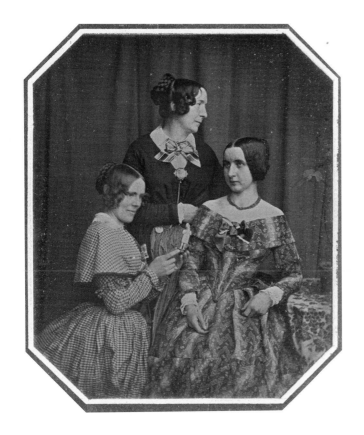

PHOTOGRAPHY AS ART

The evolution in the quality of photographs brought about by the daguerreotype and the calotype resulted in photos that were treated as works of art. Beginning in Europe in 1839, early photographers took photographs of people and landscapes that resembled oil and watercolor paintings (Figures 2.1, 2.2, and 2.3). Not only were the results of the new medium very similar to paintings, photography was much faster and, as a result, cheaper. People who had never owned a likeness of themselves could now afford one, to be hung in a place of honor at home or given as a gift.

The impact of the daguerreotype was so great, in fact, that in 1839 French painter Paul Delaroche declared that it signaled the end of painting. Although highly exaggerated, this pronouncement does indicate the effect the new medium was having.

In the ensuing discussion in France and England, three main points of view were expressed, according to photo

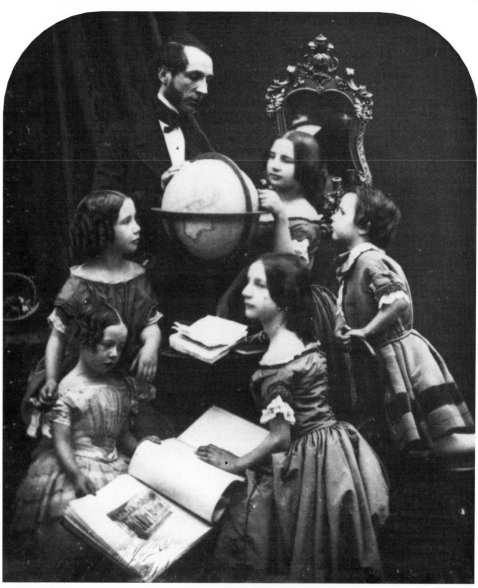

historian Naomi Rosenblum: 1) photos should not be consid-
ered art because they were more mechanical and chemical
than artistic; 2) photos, while useful to art, were not equal to
drawing and painting in their creativity; 3) photos could be
as significant as handmade works of art and might, as a
result, have a beneficial influence on the arts and culture.
Needless to say, many artists held the first two viewpoints,
photographers the third.

Like them or not, however, photographs could not be dismissed easily. From 1839 on, they were never again ignored as a new and exciting form of expression. By 1850, photographic prints were being shown in galleries next to oil paintings and watercolors.

NUDES AND OTHER SUBJECTS

The nude (Figure 2.4) was among the first subjects of these new photos as art. Nude studies done in both daguerreotypes and calotypes proliferated after 1840. Painters also began to use camera studies of nudes as first draft views of scenes they would later paint.

For all this early acclaim, nude subjects would often get photographers into trouble later in the nineteenth century when police raided studios in England and the United States and confiscated photos as lewd, indecent, and overly erotic.

Photos followed painting in another aspect as well. They were used to depict landscapes, still lifes, allegorical scenes, even literary and historical figures.

The popularity of this kind of photograph continued to grow all through the last half of the nineteenth century and into the twentieth. The daguerreotype caught on quickly as a way for people at all levels of society to possess an image of themselves and of those they loved. Daguerreotyping as a process was more commercial in the United States than in Europe. American painters did not resist using photographs in their work as their counterparts in Europe had.

Early American photographers stayed away from grandiose themes and stuck to portraits and sentimental scenes. They believed that they should not tamper with reality.

"GENRE" PHOTOGRAPHS

After the Civil War, however, the "genre" photograph—in which a scene was contrived for the camera—became popular. Soon, pictures of everyday life (Figure 2.5) and allegorical subjects (Figure 2.6) were hanging on the walls of homes all over the country.

Some English photographers began experimenting with what they called "combination printing," known today

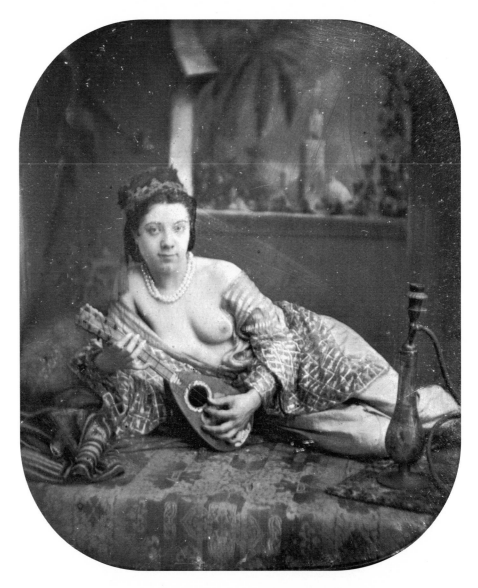

as composite photos. They produced dramatic narratives by piecing together separately photographed images (see Figure 15.4).

By the 1880s, such photos were being viewed as too contrived and naturalism emerged as the next stage of art photography. Advanced by English photographer Peter Henry Emerson, naturalistic photos reflected nature with what he called "truth." He decried the use of handwork on print or negative.

Yet another use of photography as art had begun in 1850 throughout Europe. A group of photographers set out to publish photographic prints of art masterworks. Views of these works could thus be brought to a public that had never seen them in museums. Other photographers produced staged scenes of literary figures (Figure 2.7).

The popularity of all these types of photography continued to grow as the twentieth century began. While Europe had been the center of photography in the nineteenth century, the focus now switched to the United States.

FIGURE 2.5
"THE CHESS GAME" BY ALOIS LOCHERER, 1850 [CALOTYPE]
[Courtesy of the Gernsheim Collection, Harry Ransom Humanities Research Center, The University of Texas at Austin]

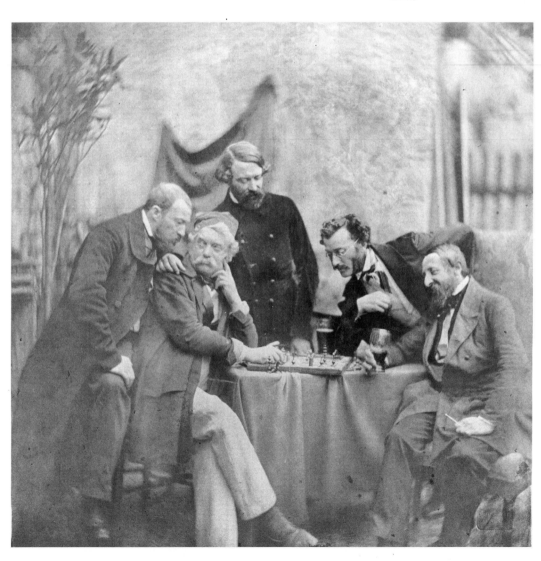

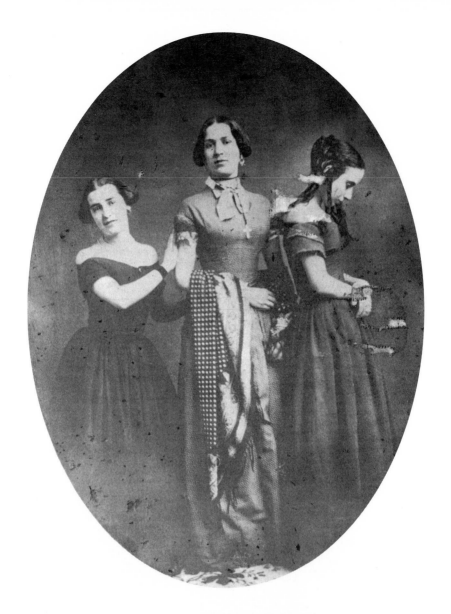

ALFRED STIEGLITZ

Alfred Stieglitz exemplified the emergence of photography as art in the United States. The American-born photographer studied in Germany for ten years, then returned to the United States in 1890 and became a partner in an engraving company. He was more interested in promoting photography as an art form, however, by writing articles for popular camera magazines of the time.

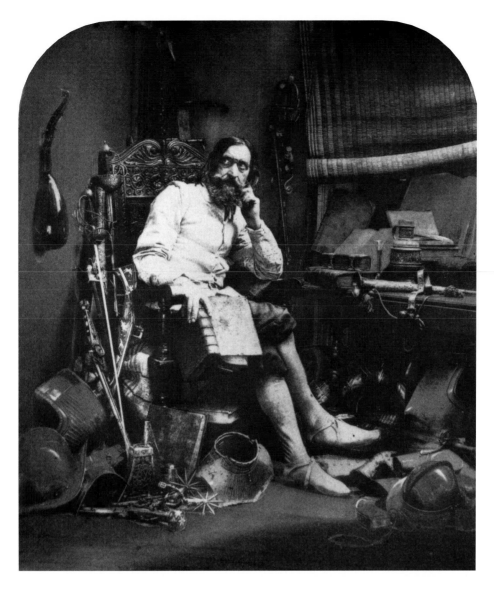

At the same time, he continued to work on his own photos, especially images of urban scenes. He opened his own gallery to feature his own works and those of other photographers. The people who patronized his gallery had never seen anything like the portraits (Figure 2.8) and views of landscapes and inanimate subjects that they found on Stieglitz's walls.

"Stieglitz's career spanned the transition from the Victorian to the modern world and his sensibilities reflected

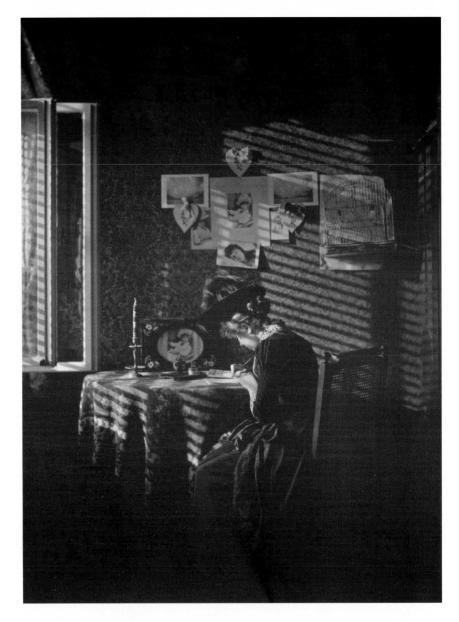

FIGURE 2.8
"PAULA" BY ALFRED STIEGLITZ,
1889 [CHLORIDE PRINT
22.7 X 16.9 CM, ALFRED
STIEGLITZ COLLECTION,
1949.698] *[Photograph courtesy of
The Art Institute of Chicago.]*

this amplitude of experience," writes Rosenblum. "His creative contribution, summed up by novelist Theodore Dreiser in 1899 as a 'desire to do new things' in order to express 'the sentiment and tender beauty in subjects previously thought devoid of charm,' was conjoined to a great sense of mission."

The later work of Alfred Stieglitz is discussed in Chapter 13.

CHAPTER 3

CAMERAS AND TECHNIQUES: FROM MOUSETRAPS TO ROLL FILM

. . . The name "Kodak" was purely an arbitrary combination of letters, not standing for anything in particular. . . .

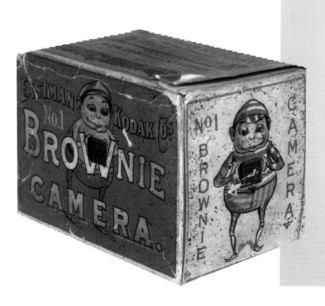

CAMERAS AND TECHNIQUES:
FROM MOUSETRAPS TO ROLL FILM

E arly camera design consisted mainly of attempts to make the camera obscura portable. Photographers could not carry around a whole room. They needed a camera that they could hold in their hands.

SIMPLE BOXES

Joseph Niepce, credited with taking the world's first photograph (see Chapter 1), used cameras designed locally. The first model, in 1816, was a six-inch square box containing a lens tube that could be focused by adjusting. He soon

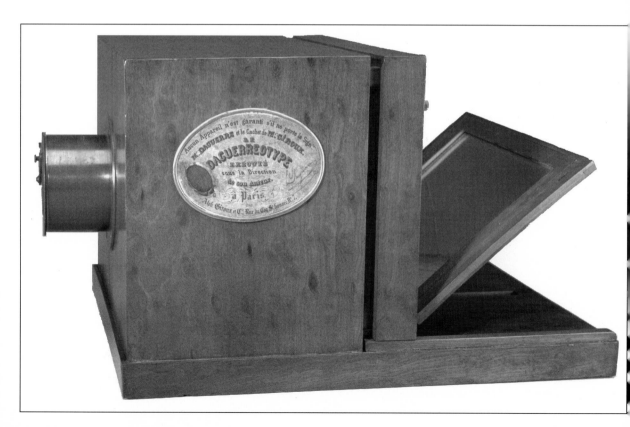

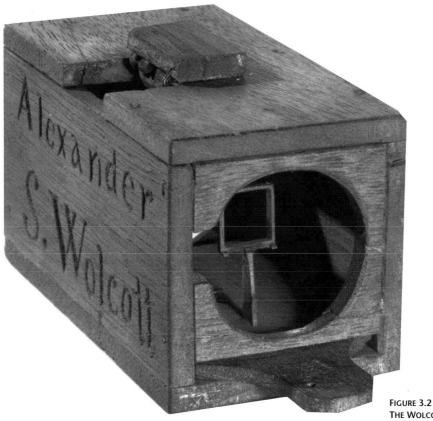

FIGURE 3.2
THE WOLCOTT MIRROR CAMERA,
1840 *[Courtesy: Smithsonian Institution
(Photo No. 697)]*

broke the lens. He then fashioned a very small camera out of his son's jewel box and added a lens from a solar microscope. A few weeks later, he made another, slightly larger, model.

The cameras that survive today in the Niepce Museum in France were made commercially and used by him between 1826 and 1833. The design consisted of two twelve-inch boxes, one inside the other. One box contained the plate holder, the other, the lens. There was no built-in diaphragm. Another camera of similar design had an accordion bellows to connect the lens panel and the ground glass. This design still is used in bellows cameras today. A bit later, a variable metal leaf iris diaphragm was added to sharpen the image. Niepce pierced some of the camera boxes with "spy" holes so he could periodically check on the progress of the image during long exposure.

Jacques Daguerre's camera (Figure 3.1) was similar to those used by Niepce—two boxes, one inside the other. He

added a pivoted cover plate to serve as a shutter. He patented it with French manufacturer Alphonse Giroux, and the camera became the first to be sold to the public in large numbers.

Englishman William Henry Fox Talbot called his first models "mousetraps." The image was photographed through the lens and affixed to thin, sensitive paper. The camera had removable holders to keep this paper in place. Fox Talbot could check on the image through a hole that was covered by a pivoted brass plate when it was not in use.

ADDING MIRRORS AND BELLOWS

In 1840, American Alexander S. Wolcott exchanged a concave mirror for the lens in order to produce a brighter image. The mirror concentrated light rays and reflected them onto the surface of the daguerreotype plate. The Wolcott camera (Figure 3.2) was patented later that year.

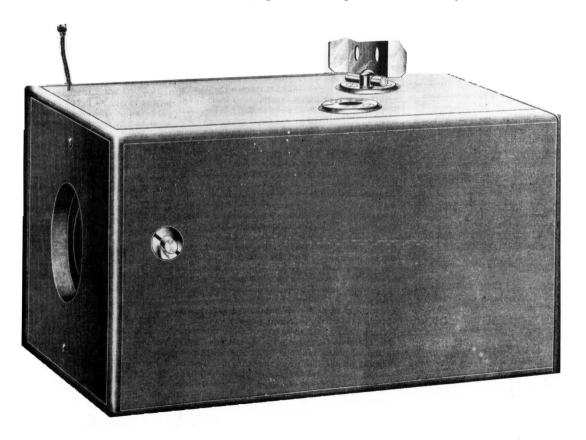

Although first suggested in 1839, the bellows focusing system was not widely used until 1851 when it was included in a rectangular camera made in New York.

In 1844, the first arc-pivoted camera was developed. It enabled a photographer to take a panoramic, 150-degree view on a curved 4 1/2 x 15 inch daguerreotype plate.

American artist David Woodward devised a means to enlarge photo negatives in 1857. He called it a solar microscope or magic lantern. It consisted of a mirror fixed at a 45-degree angle to receive the sun. These rays were reflected onto a condensing lens in a box. Negatives were fitted onto the box and an enlargement of the image was then projected onto a nearby surface.

GLASS PLATES

In addition to a number of refinements in camera design, a major change in photo development took place in the 1840s. Easily fading photographs without much definition were big problems in paper photography. The introduction of glass—instead of the grainy paper used earlier—improved sharpness. In 1847, the first practical process employed albumen or egg white as a means to fix silver salts. Glass also allowed the production of stereographic images and positive slides that could be projected. Although the grainless negatives were better than their paper counterparts, the process had drawbacks: it was complicated and the exposure time was longer than with the daguerreotype.

THE WET COLLODION

In 1850, English engraver Frederick Scott Archer published details of a means of sensitizing a colorless and grainless substance, collodion, for use on glass. Exposure time decreased greatly if the plate was used when moist. The process soon was being called the wet collodion or wet plate method. Although the procedure was messy and awkward—a photographer had to carry a portable darkroom along to sensitize each plate before using it and develop it right away—the definition was sharp and the contrast strong.

The drawbacks of the wet collodion process caused scientists, inventors, and photographers to look for improvements for the remaining years of the nineteenth century.

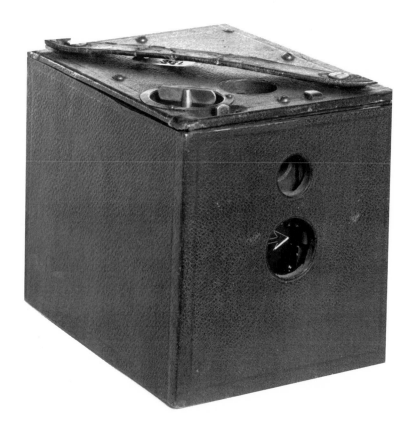

The dry plate invented in 1860 was too slow at first. In 1873, experiments by a number of inventors resulted in a dry plate that would work, largely by substituting a gelatin bromide plate for collodion.

PAPER ROLL FILM

A big advance in the process had occurred in 1854 when Arthur James Malhuish, an English inventor, came up with paper roll film. Refinements were made gradually over the years, and in 1888 the Eastman Company in Rochester, New York made it commercially available.

Initially, a gelatin emulsion had to be stripped from paper backing, transferred to glass, then developed and printed. The process was cumbersome. In 1889, transparent celluloid roll film was substituted for gelatin and the idea immediately became more practical. In 1895, paper backing

was added, so the film could be loaded in daylight. This is the roll film used by millions of photographers today.

CHANGING CAMERA DESIGN

In the meantime, camera design was changing too.

New negative materials like the dry plate and celluloid film necessitated new camera design by the 1880s. The varied plate sizes also caused a need for new camera formats.

The folding-bed view camera invented by English designer George Hare in 1882 was widely copied by others. In it, screwed rods could be manipulated to move the front panel containing a lens toward the rear panel. A folding bellows encompassed the space between. When the front panel touched the back, a hinged baseboard could be folded up and snapped shut.

The single-lens reflex camera came next. It allowed fast exposure, control over focus, and a larger size image than previously had been possible. In this design—first introduced in 1861—a mirror redirected light rays to a focusing surface of horizontal ground glass. In 1898, the introduction of the Graflex camera made the process commercially available. The Graflex followed the design of earlier models with its mirror at a 45-degree angle from the lens, focusing the image onto a screen within the camera hood that dropped out of the way

FIGURE 3.5
THE KODAK BROWNIE NO. 1, 1900
[International Museum of Photography at George Eastman House. Published with permission]

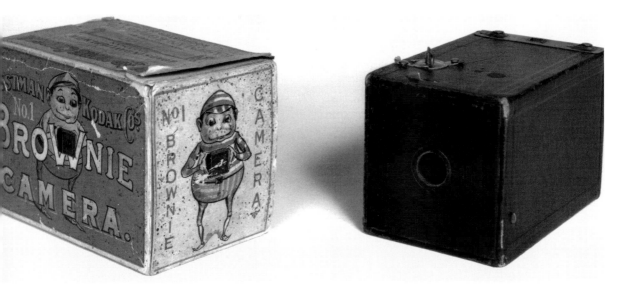

when the picture was taken. The easy-to-use camera soon became popular with news and portrait photographers and was used widely by them until well into the twentieth century.

The last truly revolutionary camera design of the pre-twentieth century period was the Eastman Kodak camera of 1888 (Figure 3.3). Its ease of operation took photography out of the hands of professionals and made it a process everyone and anyone could enjoy. The camera was advertised widely, and the public snapped it up. (The name "Kodak" was purely an arbitrary combination of letters, not standing for anything in particular.)

The camera consisted of a simple box with spools to hold roll film, a winding key to advance the film, and a string to open the shutter for exposure.

Inventor George Eastman aimed his new camera directly at the amateur market. He offered a simple camera loaded with a 100-exposure roll of film for $25. When the roll was exposed completely, the photographer returned the camera. Eastman's company developed the roll and returned the prints, along with the camera loaded with a new roll of film. The company slogan said it all: "You press the button; we do the rest."

In 1895, Eastman introduced a new model, the Bull's Eye No. 2 (Figure 3.4), the first camera to use paper-backed film. The company continued to refine its camera, introducing the Brownie No. 1 (Figure 3.5)—named for its designer Frank A. Brownell—in 1900.

PHOTOGRAPHY GOES TO WAR

. . . For the first time, dead bodies on the battlefield were a common sight, as were the badly wounded. . . . Because the photographers traveled with various U.S. Army units, they had unrivaled access to the scenes they wished to capture. . . .

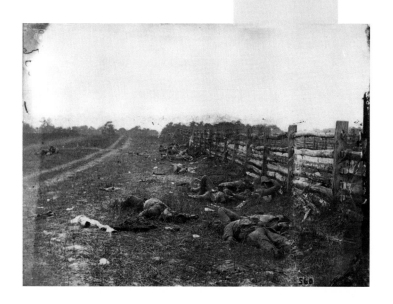

PHOTOGRAPHY GOES TO WAR

The collodion technique of photography made coverage of wars—and all news events—possible. The daguerreotype was too cumbersome a process to be practical or portable enough to serve the needs of photographers recording events as they happened. The collodion was a usable alternative.

Not that the collodion method was all that easy. Photographers captured images on glass plates and developed them in portable darkrooms ensconced in horse-drawn wagons. The difficulty was worth it, however. The wet plate process resulted in photos of unusual clarity and detail. To this day, scenes taken more than 130 years ago are breathtaking in quality. The collodion print also could be reproduced easily.

But collodion prints still had a major drawback. The glass plates still were not sensitive enough to allow photographers to capture action. As a result, war photographs from this period are of people posing, or of the dead on the battlefield.

THE CRIMEAN WAR

The Crimean War began in 1855 and was the first conflict to be recorded in photographs. William Russell, war correspondent of the *Times of London*, had been sending home dispatches questioning the efficiency of the British generals directing the war. The government wanted photographic evidence to refute Russell's claims.

Roger Fenton, who had made a good living as a society and court photographer, was hired by a publishing company to go to the Crimea. On his trek, Fenton brought two assistants and a horse-drawn wagon darkroom housing five cameras and 700 glass plates. He encountered many obstacles:

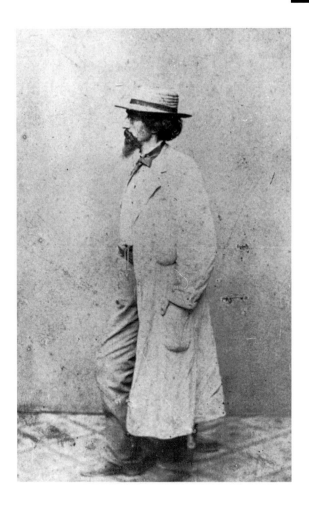

FIGURE 4.1
MATHEW BRADY [ALBUMEN PRINT]
[Courtesy of the Library of Congress]

high heat, especially in the darkroom; a great deal of dust and innumerable insects.

By the time he returned to England, Fenton had taken 360 photographs. They were an immediate sensation because of the reality of war they conveyed. For the first time, the public got to see events a few months after they had happened and as they had happened, not as seen in idealized artist's renderings.

THE AMERICAN CIVIL WAR

No war was photographed more thoroughly than the Civil War in the United States. The record of battles and individuals from the top general to the lowliest soldier was unsurpassed in scope and quality.

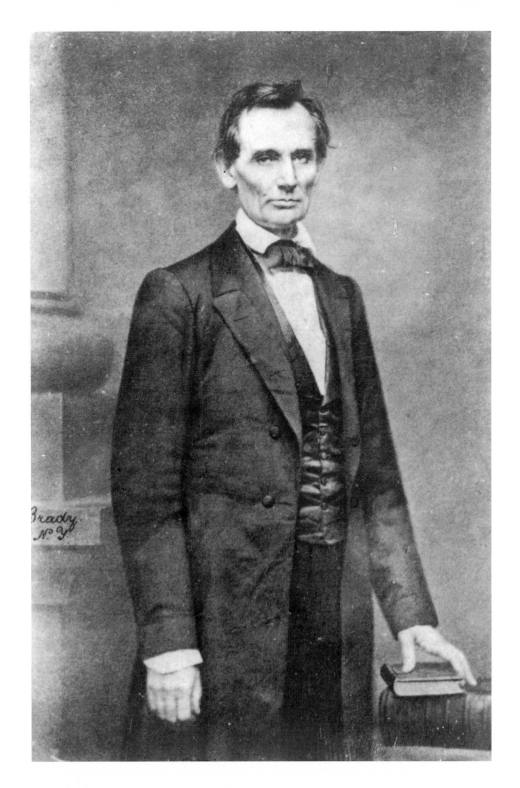

The idea of making a photographic record of the war belonged to one man, Mathew B. Brady (Figure 4.1), a successful commercial photographer who took Abraham Lincoln's campaign photograph in 1860 (Figure 4.2). (He eventually would photograph the president thirty times.)

Brady felt strongly about the need to make a photographic record of the Civil War. He even got Lincoln's help. The president wrote "Pass Brady" on a stiff card and signed it. This got Brady through the lines to battlefields. New York politicians also helped him to purchase and stock a wagon darkroom in time to photograph the First Battle of Bull Run in July 1861.

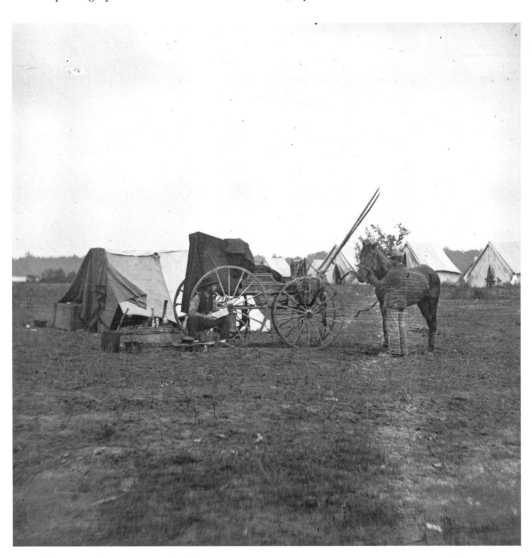

BRADY AND HIS REMARKABLE ASSISTANTS

Brady soon turned into more of an entrepreneur than a photographer. He saw the photos not only as historical documents, but as a way to make money. He hired twenty men and assigned them in teams, each equipped with wagons and supplies (Figure 4.3), to various theaters of the war. He took few war images himself.

When he published some early images in a book, *Incidents of the War*, Brady angered his chief assistant Alexander Gardner because he seemed to be taking all the credit. The book had only Brady's name on the cover. In 1863, Gardner left Brady's employ and, with his assistant Timothy O'Sullivan, set out to make his own photographs.

FIGURE 4.4
CONFEDERATE DEAD BY A FENCE ON HAGERSTOWN ROAD BY ALEXANDER GARDNER, 1863 [ALBUMEN PRINT] *[Courtesy of the Library of Congress]*

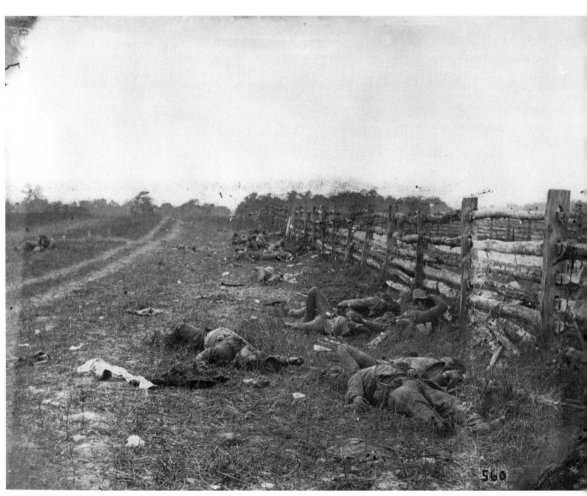

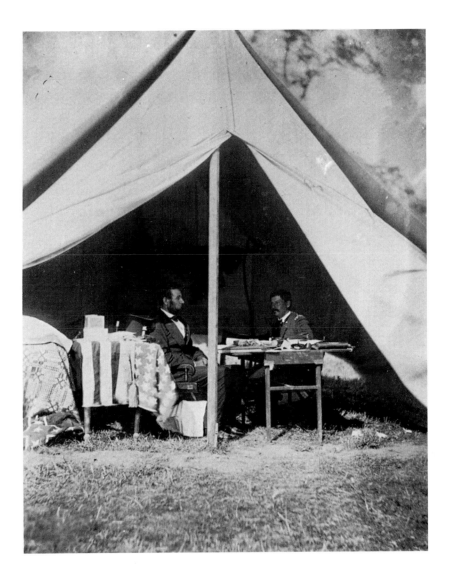

Eventually, individual photographers got some credit for their work, although history often lumps them into an amalgam with Brady listed as the source. In total, Civil War photographers took approximately 7,000 to 8,000 photos, an assemblage of images unrivaled in reality and drama until World War I (see Chapter 9) (Figures 4.4, 4.5, 4.6, 4.7, 4.8, and 4.9).

Although Brady was the visionary, Gardner was the prolific photographer, seeming to be everywhere that mattered. With O'Sullivan's help, he brought the horrors of war directly to the American public. For the first time, dead bodies

FIGURE 4.5
PRESIDENT LINCOLN VISITS GENERAL MCCLELLAN, ANTIETAM, MARYLAND BY ALEXANDER GARDNER, 1862 [ALBUMEN PRINT]
[Courtesy of the Library of Congress]

and the badly wounded on the battlefield were a common sight. Gardner was at Antietam. Both he and O'Sullivan were at Gettysburg. There, they photographed "bloated and rigid corpses piled in ditches or haphazardly strewn across fields—images that put the lie to the age-old myth of glorious death in battle," writes photo historian Vicki Goldberg.

Gardner published *Photographic Sketchbook of the War* in 1866. In the text he wrote to accompany the photos, he noted that the images conveyed a realism not possible before: "Verbal representations of such places or scenes may or may not have the merit of accuracy, but photographic presentments of them will be accepted by posterity with an undoubting faith."

FIGURE 4.6
"THE DICTATOR" A 13-INCH MOR-
TAR IN POSITION, PETERSBURG,
VIRGINIA BY DAVID KNOX, 1864
[ALBUMEN PRINT] *[Courtesy of the
Library of Congress]*

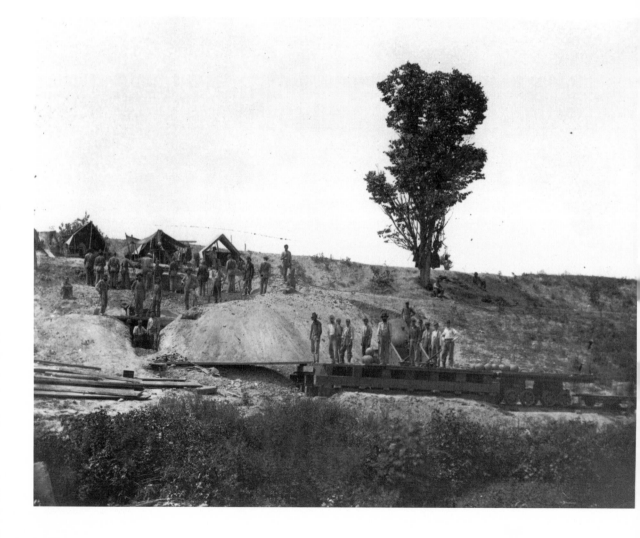

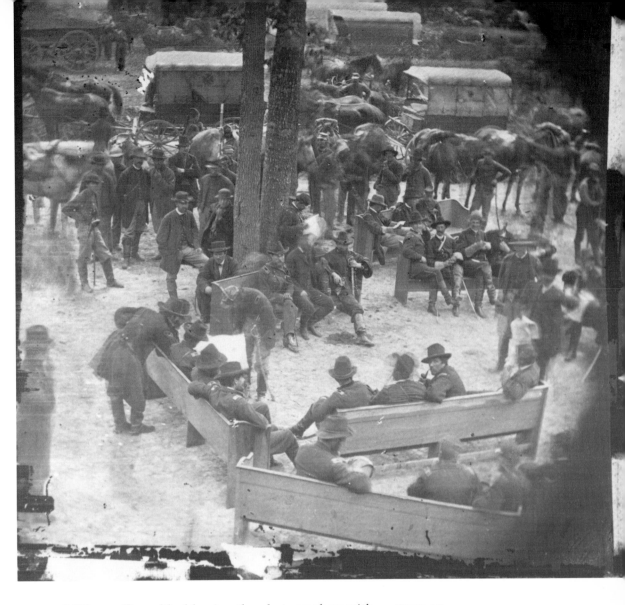

Military officers liked having the photographers with them, both for reasons of vanity and because their photos provided a complete record of battles and other activities. As a result, the photographers traveled with U.S. Army units and had unhindered access to the scenes they wished to capture on film. Ironically, the thousands of photos were never put to journalistic use. They were not published in newspapers and magazines. Instead, they were copied by sketch artists (Figure 4.10) and later appeared as engravings in *Harper's Weekly* and other publications of the time.

The photographers were on hand as the war ended, recording the events surrounding the signing of the surrender

FIGURE 4.7
COUNCIL OF WAR AT MASS-APONAX CHURCH, VIRGINIA BY TIMOTHY O'SULLIVAN, 1864 (GENERAL U.S. GRANT EXAMINES MAP HELD BY GENERAL GEORGE MEADE) [ALBUMEN PRINT]
[Courtesy of the Library of Congress]

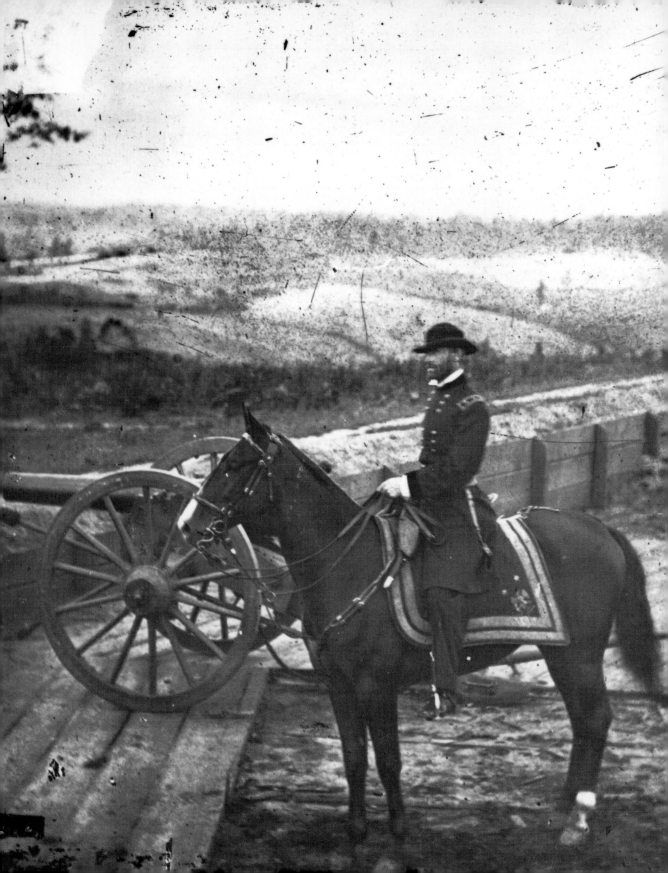

FIGURE 4.8
GENERAL WILLIAM T. SHERMAN ON
HORSEBACK AT FEDERAL FORT #7,
ATLANTA, GEORGIA, BY GEORGE
BARNARD, 1864 [ALBUMEN PRINT]
[Courtesy of the Library of Congress]

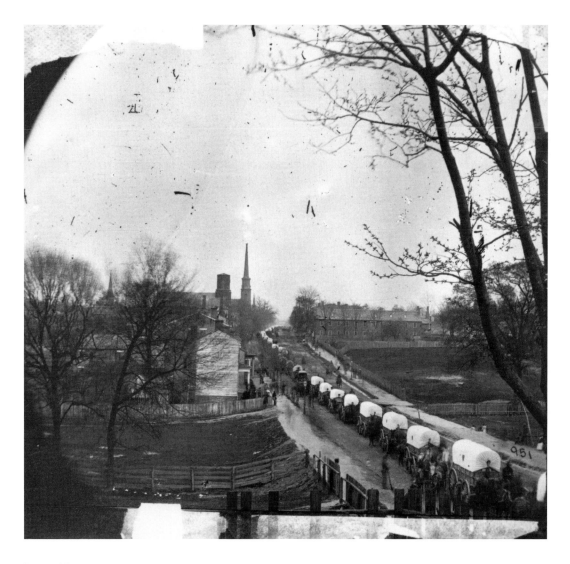

FIGURE 4.9
THE FIRST FEDERAL WAGON
TRAIN ENTERING PETERSBURG,
VIRGINIA BY J. REEKIE, 1865
[ALBUMEN PRINT] *[Courtesy of the
Library of Congress]*

FIGURE 4.10
ALFRED R. WAUD, ARTIST OF
HARPER'S WEEKLY, SKETCHING ON
BATTLEFIELD, GETTYSBURG, PENN-
SYLVANIA BY TIMOTHY O'SULLI-
VAN, 1863 [ALBUMEN PRINT]
[Courtesy of the Library of Congress]

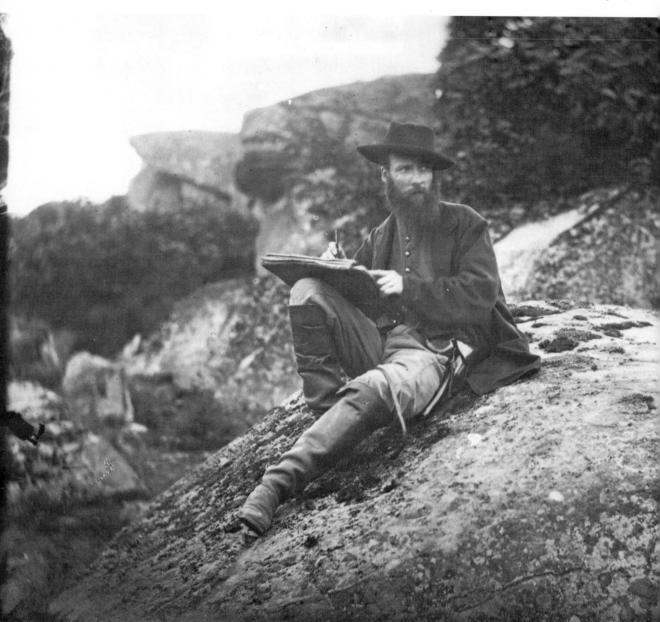

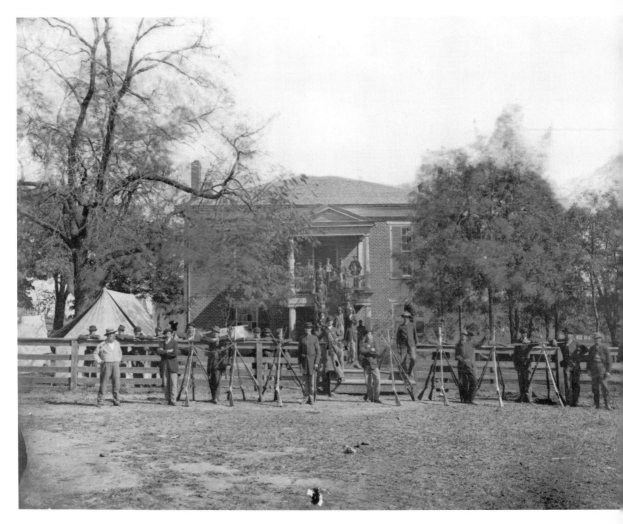

FIGURE 4.11
FEDERAL SOLDIERS AT APPOMAT-
TOX COURTHOUSE, VIRGINIA
BY TIMOTHY O'SULLIVAN, APRIL
1865 [ALBUMEN PRINT]
[Courtesy of the Library of Congress]

FIGURE 4.12
GENERAL VIEW OF THE BURNED
DISTRICT, RICHMOND, VIRGINIA
BY ALEXANDER GARDNER, 1865
[ALBUMEN PRINT] *[Courtesy of the
Library of Congress]*

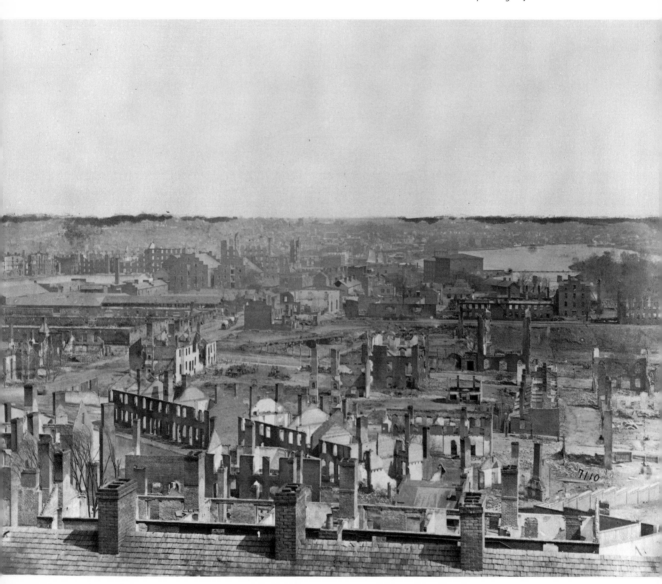

of Confederate forces at Appomattox Court House on April 9, 1865 (Figure 4.11), and the fall of the Confederate capital of Richmond at war's end (Figure 4.12).

They also photographed key events surrounding the assassination of President Lincoln that same month. They witnessed the hangings of the assassination conspirators (Figures 4.13 and 4.14). They photographed the U.S. Capitol Building still draped in mourning (Figure 4.15), a rare photo by Brady himself.

Brady had continued to direct teams of photographers up to the signing of the surrender documents at Appomattox Courthouse. He had expected to sell the photos, especially those in stereograph (three-dimensional) format, to at least make back the expenses he had incurred in this long project. But when the conflict ended, public interest in war photos ended, too. Brady's venture failed, and he faced financial ruin. Even the U.S. War Department was not interested.

Eventually, he gave one set of negatives to the T. and E. Anthony Company as payment for supplies over the years. The other set remained in storage, deteriorating, until 1871 when the U.S. government bought 5,000 negatives at auction for $2,840. The negatives were preserved carefully and made available to the public by the Library of Congress.

Several years later the U.S. Congress gave Brady $25,000 in tribute to the vision he had shown. He and the other Civil War photographers, especially Gardner and O'Sullivan, made their depictions of a national trauma into an art form, albeit a stark and horrific one.

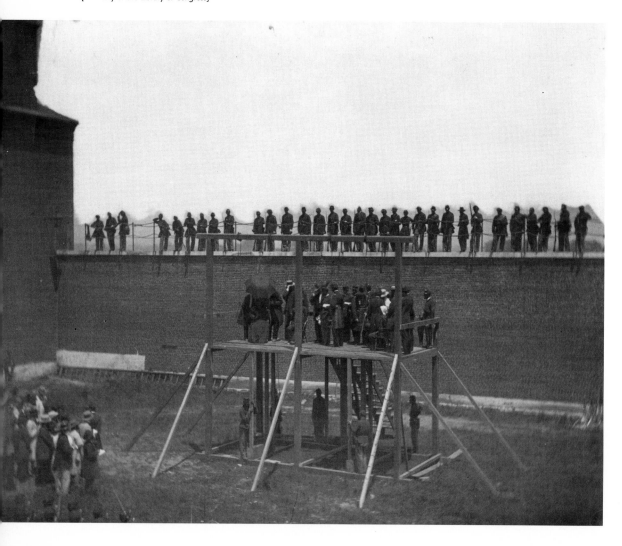

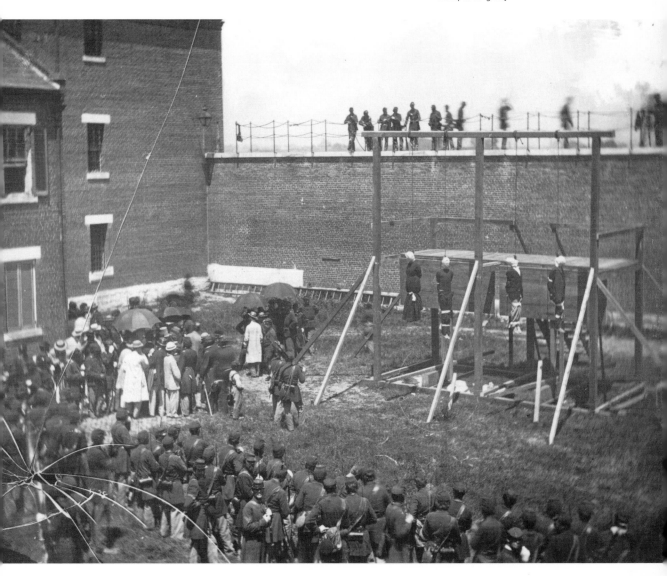

FIGURE 4.15
**SPECTATORS AT SIDE OF CAPITOL
HUNG WITH CREPE AND FLAG
AT HALF-MAST BY MATHEW B.
BRADY, MAY 1865** *[Courtesy of the
Library of Congress]*

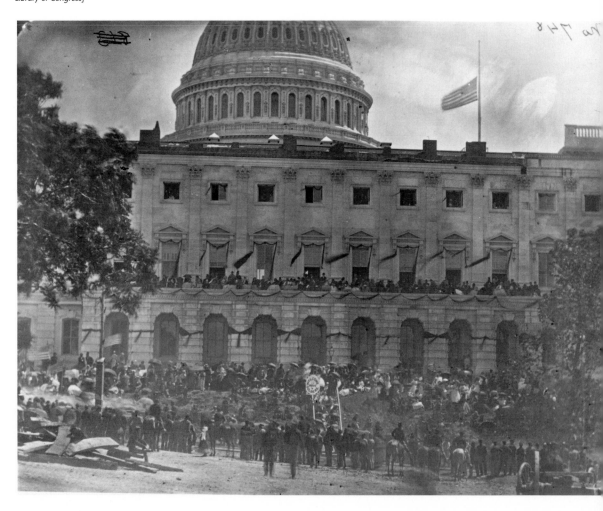

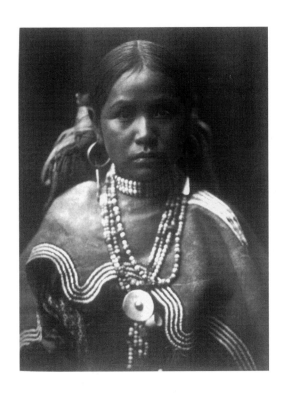

CHAPTER 5

PHOTOGRAPHY TO DEPICT PEOPLE AND THEIR LIVES

. . . Curtis recorded the everyday lives of tribes from Alaska to Texas in a remarkable series of photos, 400,000 in all. . . . He also collected 350 Indian tales and made more than 10,000 recordings of Indian speech and music.

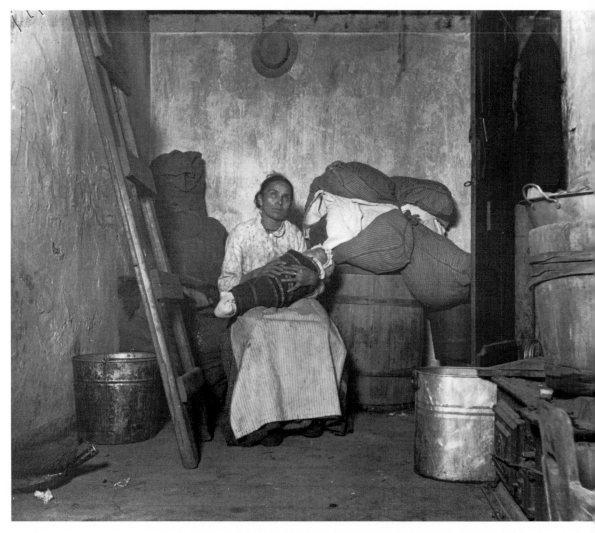

FIGURE 5.1
"IN THE HOME OF AN ITALIAN
RAGPICKER" BY JACOB RIIS
[GELATIN SILVER PRINT] *[The Jacob A.*
Riis Collection 157, Museum of the City of
New York. Published with permission]

PHOTOGRAPHY TO DEPICT
PEOPLE AND THEIR LIVES

E ven before the Civil War, photographers were taking images of real life, not scenes staged for the camera as in portraits and art shots.

In the 1840s and 1850s, publications in both the United States and Europe hired photographers to take photos to illustrate articles. In the United States, both *Harper's Weekly* (an upscale news magazine) and Frank Leslie's *Illustrated Newspaper* (a *National Enquirer*-type sensational periodical aimed at a mass audience) began to run photos to brighten up their pages.

DOCUMENTING REAL THINGS

During this period, governments and private companies saw the need for photographs to document activities. For example, the expansion into the West brought on a construction boom involving bridges, railroads, and cities. Photographers followed explorers into Yosemite as early as 1863.

Photographers who happened to be present when something newsworthy happened began to sell their photos to newspapers. This marked the beginning of photojournalism. Whether the subject was a train wreck or a mill fire, the images captured by the camera were striking and compelling to people not used to seeing anything like them.

The way people lived was the next subject for the camera's eye. As a continual tide of immigrants engulfed large American cities, their living conditions frequently were appalling. Social reformers needed proof to get governments to improve these horrible circumstances.

JACOB RIIS AND TENEMENT LIFE

In the 1880s, Jacob Riis, a police reporter for the *New York Herald,* realized early in his career that realistic photographs might cause a change in the conditions they depicted. His work showed the world of the tenement, especially a part of lower Manhattan on Mulberry Street where children lived on the street and families existed in squalor. Riis began to lecture on what he had found and used lantern slides of his photos to illustrate his main points.

Riis's 1890 book, *How the Other Half Lives: Studies Among the Tenements of New York* had a great impact on improving immigrant life. In the text he reported upon the terrible social conditions he had encountered in his investigation. He illustrated the book with forty photos, 17 of them halftone reproductions of his photographs (Figures 5.1 and 5.2).

Although Riis was more a reporter and writer than a photographer, his work had real impact. Even though some of his images were of poor quality, they publicized for the first time the feeling of degradation and despair "the other half" of his book's title encountered every day of their lives.

LEWIS HINE AND THE POOR

Equally evocative in his depiction of the underclass was Lewis W. Hine. He moved to New York in 1900 to teach science at the Ethical Culture School. In 1904, Hine began also to teach photography at the school. As a hobby, he started taking photos of immigrants as they arrived at Ellis Island.

He became interested in using the camera to improve the living and working conditions of the nation's poor. He resigned his teaching position and went into business as a professional photographer specializing in the depiction of social conditions. As such, he worked for the National Child Labor Committee for ten years and with an American Red Cross relief mission to France and the Balkans at the end of World War I.

A later assignment was his 1930 commission to photograph the construction of the Empire State Building floor by floor. At the building's completion, he organized photos from the project and his other images into *Men at Work,* an early "coffee table" book.

FIGURE 5.2
"'SCOTTY' IN HIS LAIR, A PILE
OF ABANDONED LUMBER AND
BRICKS AT THE HARLEM RIVER"
BY JACOB RIIS [GELATIN SILVER
PRINT] *[The Jacob A. Riis Collection*
185, Museum of the City of New York.
Published with permission]

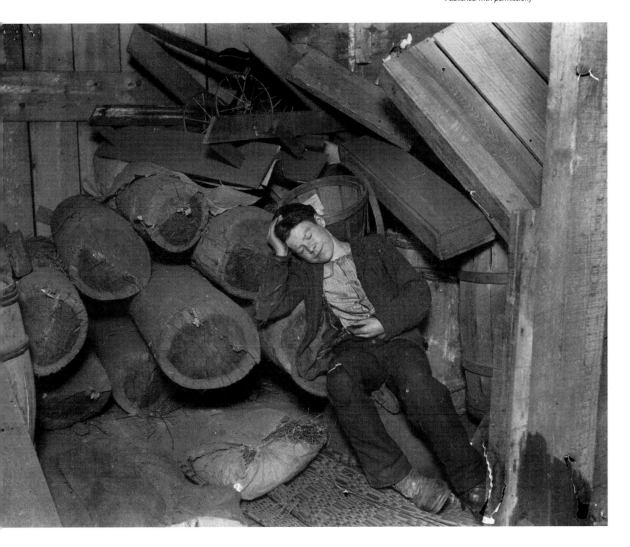

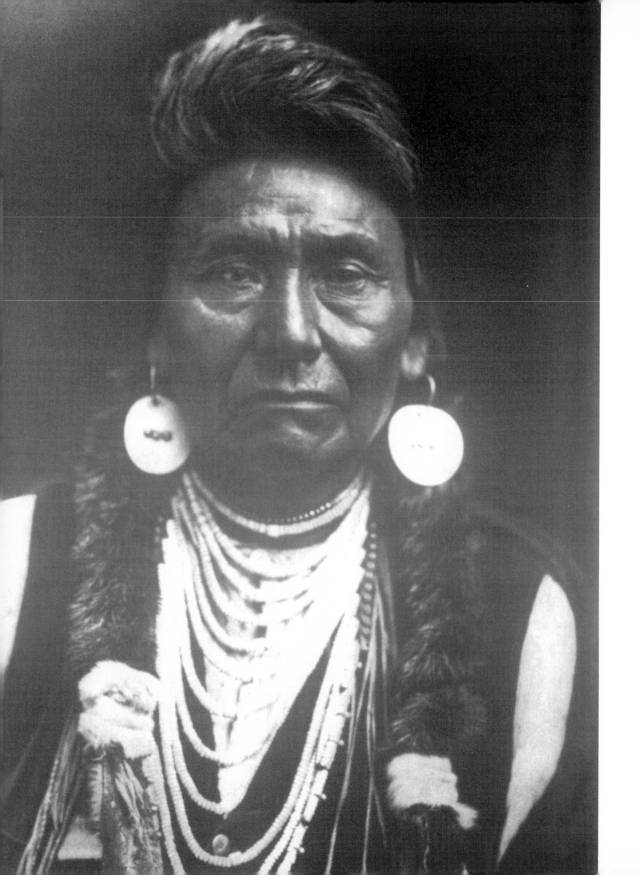

EDWARD S. CURTIS AND NATIVE AMERICANS

Documentary photography of another kind became the special province of Edward S. Curtis. The Seattle commercial photographer became interested in recording the lives of American Indians in 1895 or early 1896, when he photographed Princess Angeline, the daughter of Chief Seattle.

He began to take photos of other Indians around Puget Sound. In 1899, he signed on as official photographer for the Harriman scientific expedition to Alaska. Edward Harriman, owner of the Union Pacific Railroad, paid for the trip. The entourage included naturalist John Muir and C. Hart Merriam, chief of the U.S. Biological Survey.

Everyone on the trip had a different agenda. Harriman was exploring the possibility of building a trans-Alaska railroad that eventually might be linked with Siberia. The naturalists and scientists were seeing plants and animals never seen before. Ironically, Curtis confined his images to landscapes. It was Merriam who took photos of native faces, clothing, houses, and tools.

But Curtis, who printed everyone's work, was doubtless intrigued by Merriam's photos. He also learned about scientific methods and gained a valuable patron in the wealthy Harriman.

After the expedition, Curtis returned to his Seattle photography studio. He continued to take photos of natives living nearby. By 1901, he began to travel to photograph the Indians. He went to Montana for the Blood and Blackfoot tribes' annual sun dance, then to the Hopi reservation in Arizona.

In 1903, Curtis gave his first formal show of his growing collection of Indian photographs in Seattle. A few months later, he decided to make photographing Indians his life's work. He would, he said, photograph all of the Indian tribes who "still retained to a considerable degree their primitive customs and traditions." His experience on the Harriman Expedition seemed to have influenced him. He aimed to take photos that were artistic as well as documentary.

Curtis continued to photograph various tribes in the West, augmenting his income with lectures, the sale of prints and postcards, and magazine articles. He also made powerful allies such as Theodore Roosevelt, after he photographed the president's children. Through Roosevelt and Harriman, Curtis got an

(Opposite)
FIGURE 5.3
**CHIEF JOSEPH—NEZ PERCE
BY EDWARD S. CURTIS, 1903**
[Courtesy of Edward S. Curtis Reproductions. Published with permission]

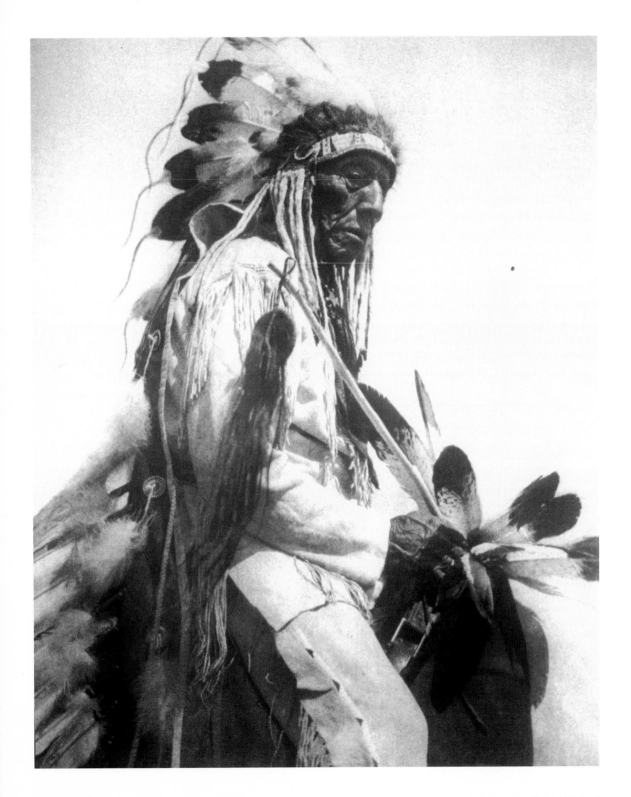

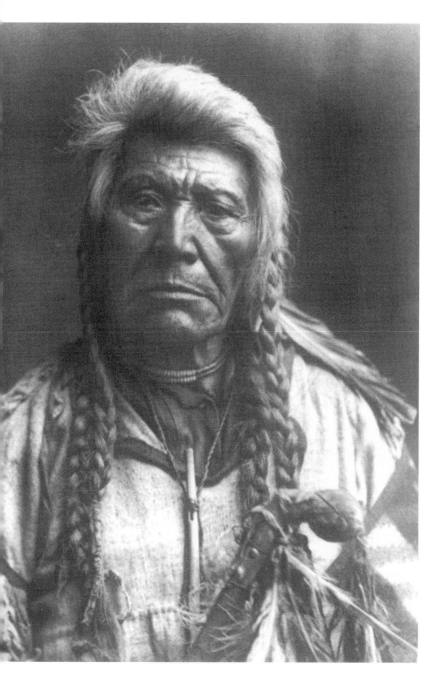

(Opposite)
FIGURE 5.4
THE OLD CHEYENNE BY EDWARD S.
CURTIS, 1927 *[Courtesy of Edward S.*
Curtis Reproductions. Published with
permission]

FIGURE 5.5
A FLATHEAD CHIEF
BY EDWARD S. CURTIS, 1900
[Courtesy of Edward S. Curtis Reproductions.
Published with permission]

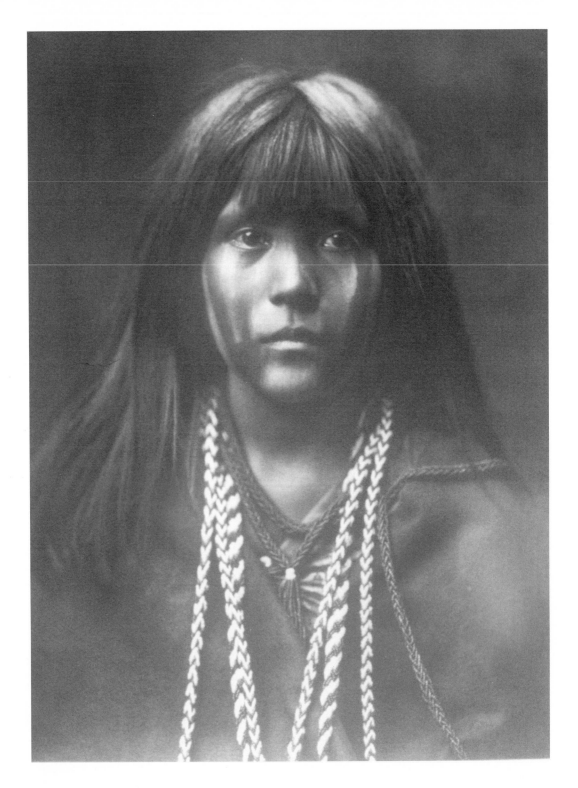

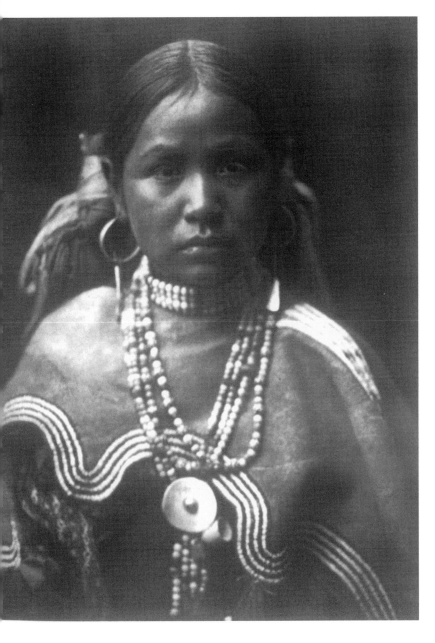

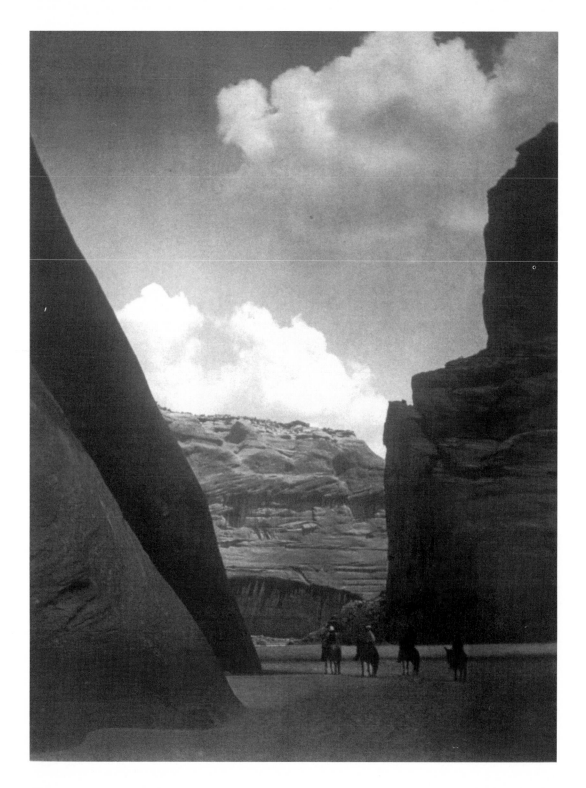

appointment with New York banker J.P. Morgan. At a meeting in January 1906, Morgan agreed to give Curtis $15,000 a year for five years. For his $75,000, Morgan was to get 25 sets and 300 large prints. Curtis used the money for his field work, paying for train travel, assistants, supplies, and lodging. Morgan expected Curtis to raise money for his own salary by selling individual prints and publishing books of his Indian photographs.

For the next 30 years, Curtis recorded the everyday lives of tribes from Alaska to Texas in a remarkable series of photos, 400,000 in all, published in four books entitled *The North American Indian* (Figures 5.3, 5.4, 5.5, 5.6, 5.7, and 5.8). He also collected 350 Indian tales and made more than 10,000 recordings of Indian speech and music.

Curtis died in 1948, his work largely ignored and forgotten. Since 1970, a renewed interest in Indian life and culture has brought increasing attention to Curtis and his remarkable photographs.

"The incredible dedication and monumental compulsion that drove Edward Curtis can hardly be imagined," wrote Bill Holm in the foreword to a Curtis biography. "It broke his health, ruined his marriage, and left him in debt. Yet he never gave up, and saw his project to completion."

In addition to living conditions and compelling faces, photographers of the period immediately following the Civil War were recording images of the changing world around them (Figure 5.9) and of great events such as the uniting of two railroads in Utah in 1869 (Figure 5.10) and the construction of the Brooklyn Bridge (Figure 5.11).

(Opposite)
FIGURE 5.8
CANYON DEL MUERTO
BY EDWARD S. CURTIS
[Courtesy of Edward S. Curtis Reproductions. Published with permission]

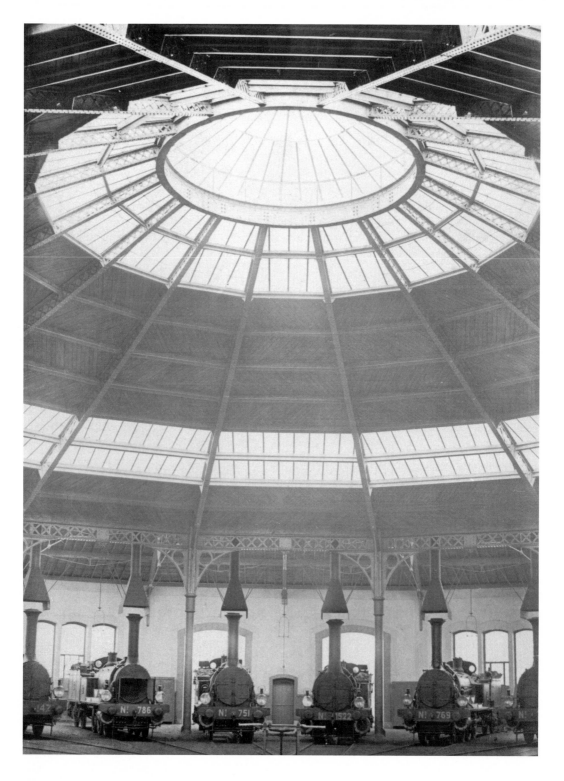

(Opposite)
FIGURE 5.9
ROUNDHOUSE ON THE BOURBONNAIS
RAILWAY, NEVERS BY A. COLLARD,
1860-1863 [ALBUMEN PRINT]
[International Museum of Photography
at George Eastman House. Published
with permission]

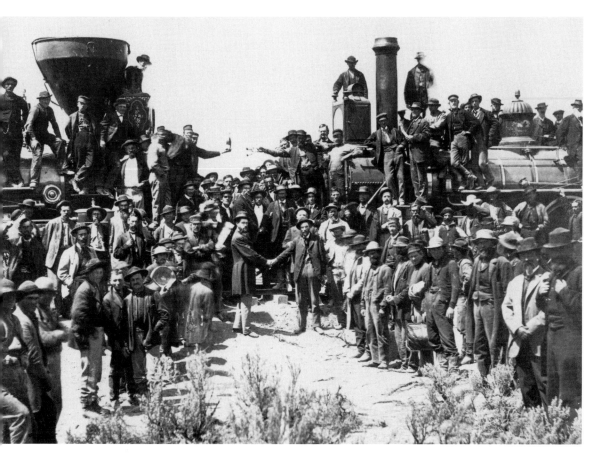

FIGURE 5.10
"MEETING OF THE RAILS,"
PROMONTORY POINT, UTAH
BY ANDREW J. RUSSELL, 1869
[ALBUMEN PRINT] *[Courtesy of the Union*
Pacific Museum. Published with permission]

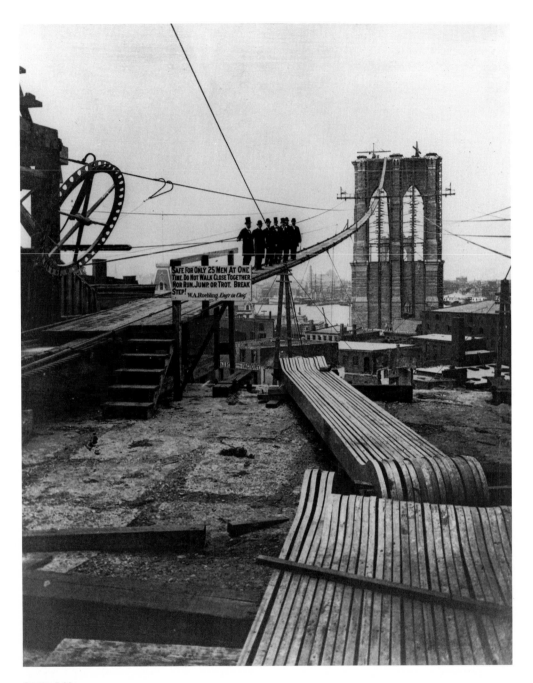

FIGURE 5.11
BROOKLYN BRIDGE
UNDER CONSTRUCTION, 1879
[ALBUMEN PRINT] *[Collection of The*
New-York Historical Society. Published
with permission]

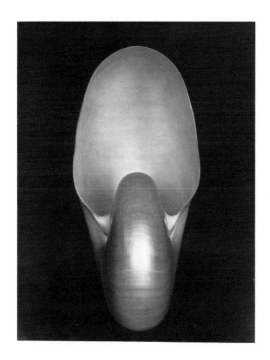

PHOTOGRAPHY
TO DEPICT NATURE

No longer would acceptable subjects for the camera's eye be limited to people, news events, and art objects . . . nature in all its wonder and glory would be appropriate too.

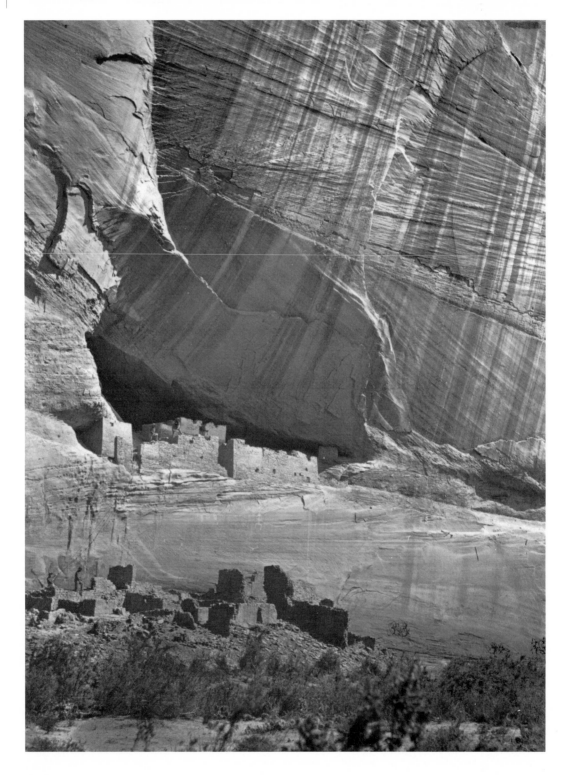

PHOTOGRAPHY TO DEPICT NATURE

Nature was the next subject to capture the attention of photographers.

MUYBRIDGE'S "YO-SEM-I-TE"

Eadweard Muybridge, an Englishman, was an early photographer of the American West. The photos that he took in Yosemite Valley in the summer and fall of 1867 began his career as a photographer. The journey to what he called "Yo-Sem-I-Te" was quite an adventure for a foreigner used to more benign surroundings.

He later published 260 views of the valley, 100 of them mounted photographs available for sale and 100 as stereotypicon (three-dimensional) slides through a gallery in San Francisco.

Photo historian Naomi Rosenblum notes that Muybridge imprinted his own style on his photos with his selection of viewpoints and the way he disposed figures in the landscape. So conscious was he of artistic landscape style that he sometimes printed clouds from separate negatives so the contrast between foreground and sky would not be too great.

Later, Muybridge gained fame as the first photographer to capture motion. Under the sponsorship of former California governor Leland Stanford, Muybridge took photos of the governor's racehorse "Occident." The photos originally were made to help Stanford win a $25,000 wager that a galloping horse, at some point in its stride, lifts all four hooves off the ground. After many attempts, Muybridge developed a camera shutter that opened and closed for only two-thousandths of a second, enabling him to capture on film a horse virtually flying through the air. The shutter was very influential in the invention of the motion picture camera. He later collaborated with the painter Thomas Eakins to study human movement.

TIMOTHY O'SULLIVAN'S GEOLOGIC JOURNEYS

While Muybridge was trekking through Yosemite, another photographer from a different background was finding new subjects and inspiration in the West.

After the Civil War, Timothy O'Sullivan returned to commercial studio work. He quickly found this kind of photography too dull. In 1867, a U.S. government geological survey hired him as official photographer. For more than two years, he took hundreds of never-before-seen images of the Western landscape along the 40th Parallel. Later, he joined another team exploring the 100th Parallel. Working from a wagon-mounted darkroom, O'Sullivan produced remarkable images on glass plates as he endured a great many hardships.

In 1873, O'Sullivan joined another expedition, this time to the Southwest. Here he took photos not only of geological formations but of the Indians living in pueblos and cliff dwellings such as Canyon de Chelle (Figure 6.1). He later was hired as the first photographer of the U.S. Geological Survey in 1879, and worked for them until tuberculosis forced him to resign. He died the next year at the age of 42.

WILLIAM HENRY JACKSON'S AMERICAN WEST

William Henry Jackson fought in the Civil War and worked as a teamster on the American plains. It was his job as the official photographer for the United States Geological and Geographical Survey of the Territories that brought him fame.

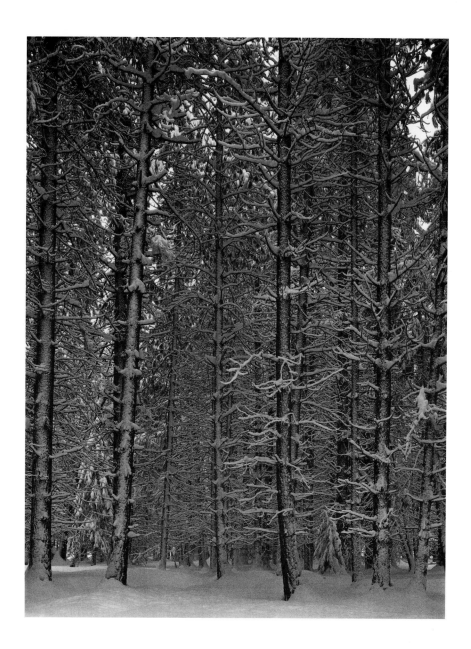

During this eight-year period, Jackson had the opportunity to take photos of a West few people had seen before.

 His work began in 1870 in the Uinta Mountains of Utah and expanded later to the Grand Canyon and Yellowstone River. Although his photos were primarily intended for scientific purposes, they quickly attracted public attention. Publishers were

anxious to use landscapes in their books and scientists and members of Congress wanted such views included in the lantern slide lectures they gave to increase funding.

Later in his career, Jackson established his own business and specialized in selling photos of the West. Jackson wrote his autobiography *Time Exposure* in 1940, when he was 97. He died the next year, unequaled in the longevity of his career and in the scope of his portrayal on film of a swiftly vanishing American West.

In more recent years, two photographers made their reputations by photographing landscapes and natural objects, primarily in the West. Both Ansel Adams and Edward Weston gained fame with images of nature.

ANSEL ADAMS AND THE GREAT OUTDOORS

Ansel Adams first read about Yosemite National Park in April 1916 while he was recuperating from a childhood illness. He noted in his 1985 autobiography that he became "hopelessly enthralled" with descriptions he read of the park and asked his parents to take him there. The following June, Adams and his mother and father traveled to the park and the 14-year-old boy saw for the first time a region that would form the center of his career as the country's foremost nature photographer.

Adams also got his first camera on that trip—a Kodak Box Brownie. After reading the instructions for a few minutes, "my camera and I went off to explore," he recalled in his autobiography. That early and rather primitive foray into Yosemite would change photography forever. No longer would acceptable subjects for the camera's eye be limited to people, news events, and art objects. After Adams, nature in all its wonder and glory would be appropriate too.

Adams said his decision to devote his life to photography meant that he had to make a living at it. He did commercial work beginning in 1930, to pay for the artistic work he is best known for.

During this period, Adams began to take nature photographs (Figure 6.2). He also started organizing exhibitions and writing about his photographic techniques. He wrote his first technical book, *Making a Photograph,* in 1935. He would go on to write a number of other books explaining

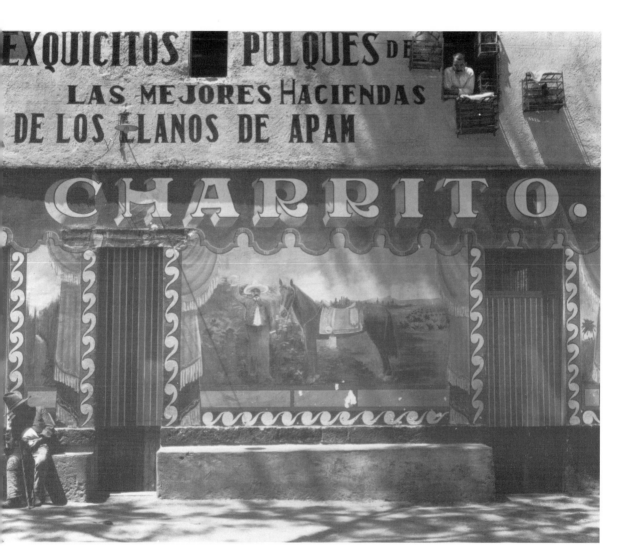

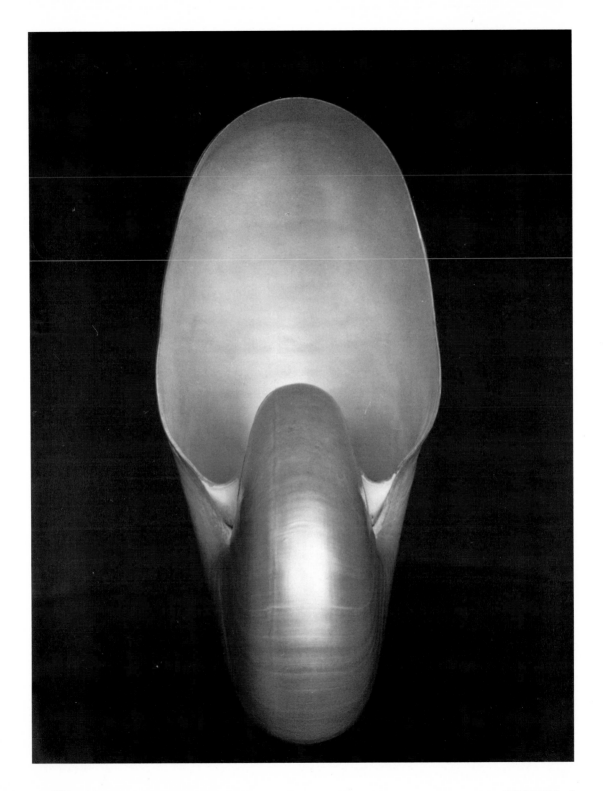

his philosophy of photography and displaying his remarkable photos.

Adams also taught photography throughout his career, leading groups of students hundreds of times to Yosemite and other areas. Once there, he showed them how to take photos of the natural world. Early in his career as a teacher, Adams worked out a method of giving his students "technical command of the medium." His "zone system" is a framework for understanding exposure and development and visualizing their effect in advance, as defined in his book, *Examples: The Making of 40 Photographs:*

> . . . *Areas of different luminance in the subject are each related to exposure zones and these in turn to approximate values of gray in the final print. Thus careful exposure and development procedures permit the photographer to control the negative densities and corresponding print values that will represent specific subject areas, in accordance with the visualized final image.*

Ansel Adams' remarkable life ended on April 22, 1984. No one had quite seen nature as he had. "The visualization of a photograph involves the intuitive search for meaning, shape, form, texture, and the projection of the image-format on the subject," he wrote. ". . . The creative artist is constantly roving the worlds without, and creating new worlds within."

EDWARD WESTON AND NATURAL OBJECTS

Equally compelling in his often provocative depiction of natural objects was Edward Weston.

Weston's first camera was a Kodak Bull's-Eye, which his father sent him to play with during a summer vacation in Michigan in 1902. He immediately was excited by his new toy and began to read photo magazines to learn about photographic techniques. After he saw a view camera in the window of a Chicago pawnshop, Weston saved the money to buy it.

Writes his biographer, Nancy Newhall:

> . . . *From then on, he played hooky from school until it was obvious his academic career was at an end; he was*

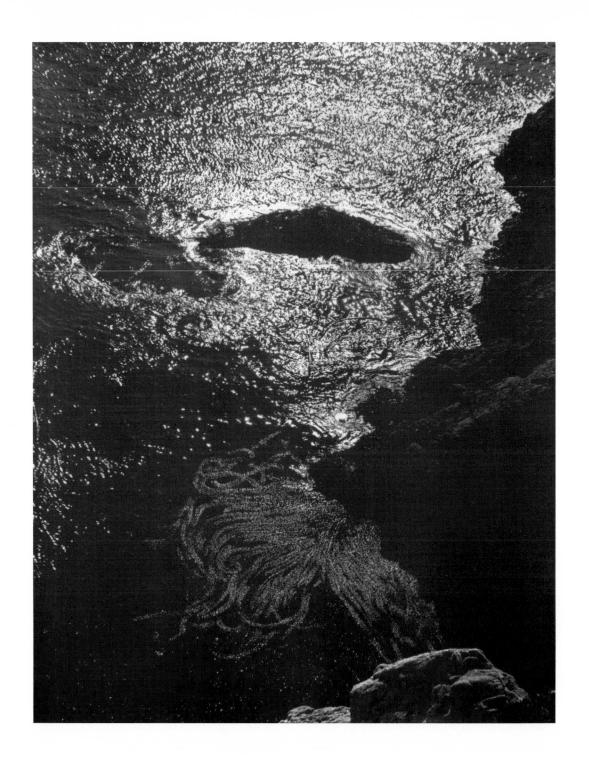

always out with his camera photographing the southern parks, the prairies, the lakes. When, in 1903, a photographic magazine reproduced a little spring landscape, Edward was lost forever to photography.

After a vacation to California in 1906, Weston returned to Chicago and took a course in portrait photography at the Illinois College of Photography. He then went back to California to work as a printer for local portrait photographers.

He got married in 1909 and opened his own studio in Tropico, California, in 1911. According to Newhall, his income the first week was $1 for a dozen postcards. He started trying new techniques, both in arranging his subjects for their portraits and in printing the photos that resulted. He began to disdain artificial light and started to do more and more of his work outside. Newhall says he became absorbed by the problems and the beauty of natural light. The result, which he called "spontaneous" portraits, attracted attention.

By 1914, Weston's fame was spreading, particularly for what he called his "high-key" portraits, which Newhall describes as photos with "striking tonal arrangements, imaginative use of natural light seen in soft focus."

Although elected as a member of the prestigious London Salon in 1917, Weston was beginning to rebel against the pictorialism that that august organization represented. Alfred Stieglitz and Edward Steichen were leading the attack against that movement. They were both opting for more simplicity.

Newhall says that Weston was seeking "bolder structure, deep space, sharper seeing, a more humble and objective approach to life." He was looking for more simplicity in his personal life as well. He left his wife and four sons and moved to Mexico in 1922 where he lived for four years operating his own portrait studio and taking photographs of the sights he encountered (Figure 6.3).

In 1927, Weston returned to the United States and began to photograph the subjects that would make him famous: single, ordinary objects like vegetables, fruit, rocks, tree roots, shells (Figure 6.4), even household tools viewed in unusual and often provocative ways.

In 1937 and 1939, Weston received grants from the Guggenheim Foundation that allowed him to do his creative

(Opposite)
FIGURE 6.5
"KELP, CHINA CAVE, POINT LOBOS" BY EDWARD WESTON, 1940 [GELATIN SILVER PRINT]
[©1981 Center for Creative Photography. Arizona Board of Regents]

work without worrying about finances. Beginning in this period, Weston concentrated on perfecting his photos of natural things (Figure 6.5) and of the nude figure.

He also left behind a daily journal that he kept for twenty years beginning in 1923. *Daybooks*, published in 1961, records how a photographer thinks and works.

> *"Photography is, or can be, a most intellectual pursuit. In painting or sculpture or what not, the sensitive human hand aids the brain in affirming beauty. The camera has no such assistance, unless, of course, the process after exposure has been interfered with, and hence ruined, by manipulation, manual dexterity."*
>
> — January 15, 1926
> *The Daybooks of Edward Weston*
> Vol. I, Mexico, page 147
> [Millerton, New York: Aperture, Inc., 1961]

> *". . . photography suits the tempo of this age—of active bodies and minds. It is a perfect medium for one whose mind is teeming with ideas, imagery, for a prolific worker who would be slowed down by painting or sculpture, for one who sees quickly and acts decisively, accurately . . . It is an abominable medium for the slowwitted, or the sloppy worker . . . One has a background of years—learning—unlearning—success—failure—dreaming—thrilling—experience—back it goes—farther back than one's ancestors: all this, then the moment of creation, the focusing of all into the moment. So I can make—'without thought'—fifteen carefully-considered negatives one every fifteen minutes—given materials with as many possibilities."*
>
> — June 19, 1930
> *The Daybooks of Edward Weston*
> Vol. II, California, pages 168-169
> [Millerton, New York: Aperture, Inc., 1961]

PHOTOGRAPHY AND THE DEPRESSION: THE FARM SECURITY ADMINISTRATION

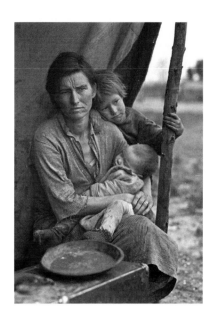

Although she spent only ten minutes taking six exposures of the woman, Lange captured the plight of millions of Americans—and the conscience of millions more—with her haunting photographs.

PHOTOGRAPHY AND THE DEPRESSION: THE FARM SECURITY ADMINISTRATION

FIGURE 7.1
FLOOD REFUGEES, FORREST CITY,
ARKANSAS, BY WALKER EVANS,
1937 [GELATIN SILVER PRINT]
[Courtesy of the Library of Congress]

On the face of it, President Franklin D. Roosevelt's organization of the Resettlement Administration in 1935 would appear to have very little to do with photography. The New Deal federal agency was set up to provide low interest loans to poor farmers, carry out land renewal projects such as reforestation, and sponsor camps for migrant farm workers desperately in need of work and housing.

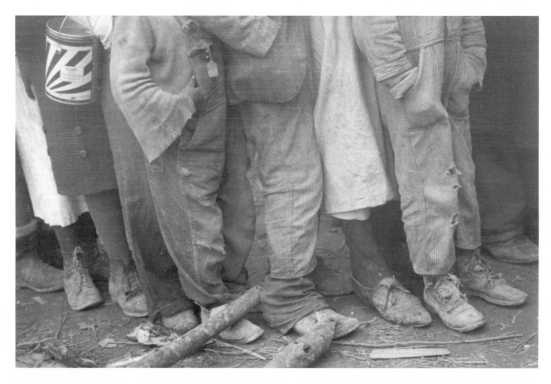

PHOTOGRAPHING THE "SUBMERGED THIRD"

The president appointed Rexford Guy Tugwell, a professor of economics at Columbia University, to head this new unit. Tugwell put his former graduate assistant, Roy Stryker, in charge of the information division of the agency's historical section. This is where photography came in. Photographs quickly became a part of the mission of the historical section: to record how what Tugwell called the "submerged third" of the United States population was coping with economic depression and displacement from their homes (Figure 7.1). (In 1937, the Historical Section was transferred to the Department of Agriculture and made a part of the Farm Security Administration.)

For Stryker, the assignment offered the opportunity to use photography as a tool for change. He wanted to show the two-thirds of Americans who were relatively prosperous how horribly some of their countrymen were living.

Stryker began by collecting photographs already in government files for use in news releases and brochures published by the Resettlement Administration. At the suggestion of his boss, Tugwell, Stryker developed the concept of traveling photographers. The economist believed that worn-out soil caused a lot of agrarian poverty. If this land could be identified and photographs taken of it, people living on it could be settled in more productive areas, Tugwell believed.

Several months later, Tugwell gave Stryker control over all photography in the Resettlement Administration. Stryker's plan was to hire a task force of thirty or forty photographers to travel across rural America to take shots of adverse conditions and that agency's efforts to change them. The photographers would report back between trips and develop their negatives and make prints in a central darkroom in Washington. Resettlement Administration publicity people then would use this file to supply photographs to Congressional committees, other government agencies, and the press.

This concept was easier to promulgate, however, than turn into reality. For one thing, Stryker had budget problems from the start. He didn't have the money to hire the number of photographers initially envisioned. Worse, government accountants were unsympathetic to charges for film, cameras, and other supplies. They even balked at paying automobile

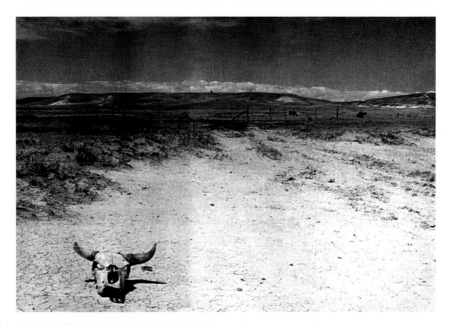

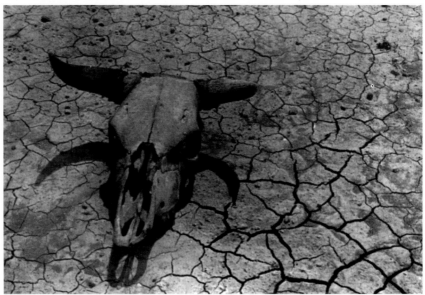

FIGURE 7.2A AND 7.2B
STEER SKULL, PENNINGTON
COUNTY, SOUTH DAKOTA BY
ARTHUR ROTHSTEIN, 1936
[GELATIN SILVER PRINT]
[Courtesy of the Library of Congress]

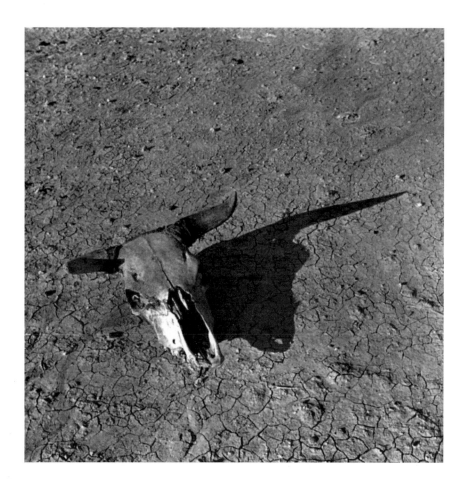

FIGURE 7.2C
STEER SKULL BY ARTHUR
ROTHSTEIN, 1936 [GELATIN
SILVER PRINT] *[Courtesy of the
Library of Congress]*

expenses. Members of Congress also complained when photographers went into their districts, hoping, no doubt, to keep the often deplorable conditions hidden.

Stryker reacted to the complaints by demanding greater output from his photographers. "Let me warn you that you must push as hard as possible and get your pictures done," he wrote to one.

ASSEMBLING AN OUTSTANDING STAFF

Ironically, Stryker himself did not take one photograph. He was fortunate in his choice of those to do so, however. His first employee was Arthur Rothstein, who set up the files and darkrooms. Later, Rothstein traveled to the Dust Bowl, where he photographed, among other subjects, a steer

FIGURE 7.3
CHURCH INTERIOR, ALABAMA BY
WALKER EVANS, 1936 [GELATIN
SILVER PRINT] *[Courtesy of the Library of Congress]*

skull bleached from the searing sun (Figure 7.2A). Because he had taken the skull from more than one angle (Figure 7.2B) and even moved it (Figure 7.2C), Rothstein set off a controversy about the truthfulness of images and of documentary photography as a whole.

Stryker and other photographers supported Rothstein. Another of the photographers, Walker Evans, did not. Evans clashed with Stryker over the need to depict scenes as he found them (Figure 7.3), not to recreate them for

the camera as Stryker, ever the government propagandist, might want him to do. "Documentary . . . [is] a misleading word," Stryker wrote in 1971. ". . . The term should be documentary style . . . You see, a document has use, whereas art is really useless."

The conflict caused Stryker to release Evans from the photo project in 1936 to work with writer James Agee for *Fortune* magazine on an article about tenant farmers in the South. They later expanded their work into a book, *Let Us Now Praise Famous Men,* in which Evans' haunting photos accompanied Agee's classic text. Due to the controversy, however, Stryker and most of the other photographers in the agency ignored the book when it was published in 1941.

Stryker also hired Ben Shahn and sent him to the Midwest, and Carl Mydans, who took photos in the South. He hired Russell Lee and John Vachon to record small town life (Figure 7.4).

FIGURE 7.4
COUNTRY DOCTOR AND PATIENT IN FARM HOME, SCOTT COUNTY, MISSOURI BY JOHN VACHON, 1942 [GELATIN SILVER PRINT]
[Courtesy of the Library of Congress]

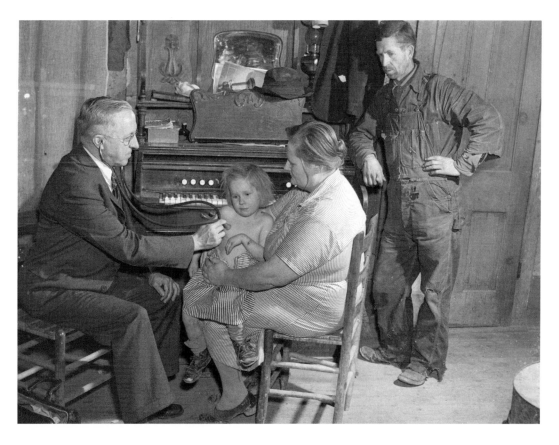

DOROTHEA LANGE'S MIGRANT MOTHER

Dorothea Lange, already famous when she joined the project in 1935, also clashed with Stryker. She was similar to Evans in the established artistic credentials and influential connections she brought with her. For these reasons, both photographers often were at odds with Stryker, who wanted an ordered bureaucratic structure, not two photographers constantly doing what *they*, not Stryker, wanted to do.

Lange insisted on working out of her California studio in Berkeley and on developing and printing her own film.

FIGURE 7.5
TOWN SUFFERING FROM THE
DEPRESSION AND THE DROUGHT
IN SURROUNDING FARMLAND,
CADDO, OKLAHOMA BY
DOROTHEA LANGE, 1938
[GELATIN SILVER PRINT]
[Courtesy of the Library of Congress]

She asked for—and Stryker reluctantly agreed to—her right to retain copies of her photos for her own use. Stryker required the other photographers to give all prints and negatives to the FSA's central archive in Washington.

Lange's many memorable images came largely by happenstance and luck. Her procedure on field trips was not to plan her route in detail. Instead, she started out in one direction and drove until she saw something she deemed worth photographing (Figure 7.5).

Her technique included spending a lot of time with her subjects, talking to them at length, and capturing their lives as they lived them. "If you see mainly human misery in my photographs," she said, "I have failed to show the multi-form pattern of which it is a reflection. For the havoc before your eyes is the result of both natural and social forces."

Her photograph, "Migrant Mother," became a symbol of the Depression (Figure 7.6). Lange took it at the end of her first field trip. She already had passed the entrance to a pea pickers camp near Nipomo, California on a March day in 1936 when she decided to turn back and drive in. When she got there, she immediately saw the woman sitting in her rundown tent with two of her seven children. The woman told Lange the family was living on wild birds the children had caught. There was no work because the pea crop froze on the ground. She could not move on, however, because she had sold the tires on her car to pay for food. Although she spent only ten minutes taking six exposures of the woman, Lange captured the plight of millions of Americans—and the conscience of millions more—with her haunting photographs.

In April 1938, the First International Exposition of Photography opened in New York's Grand Central Palace. Included was "How American People Live," a small exhibit of work by FSA photographers. This marked the national debut of the striking images these dedicated men and women had been assembling for three years. Although many photos appeared in various government publications, none had been displayed in large size and in a gallery setting before. The views—starkly captioned "Tubercular Mother and Child—New York" or "Sharecropper's Family—Alabama"—revealed as never before the consequences of the agricultural depression in the United States.

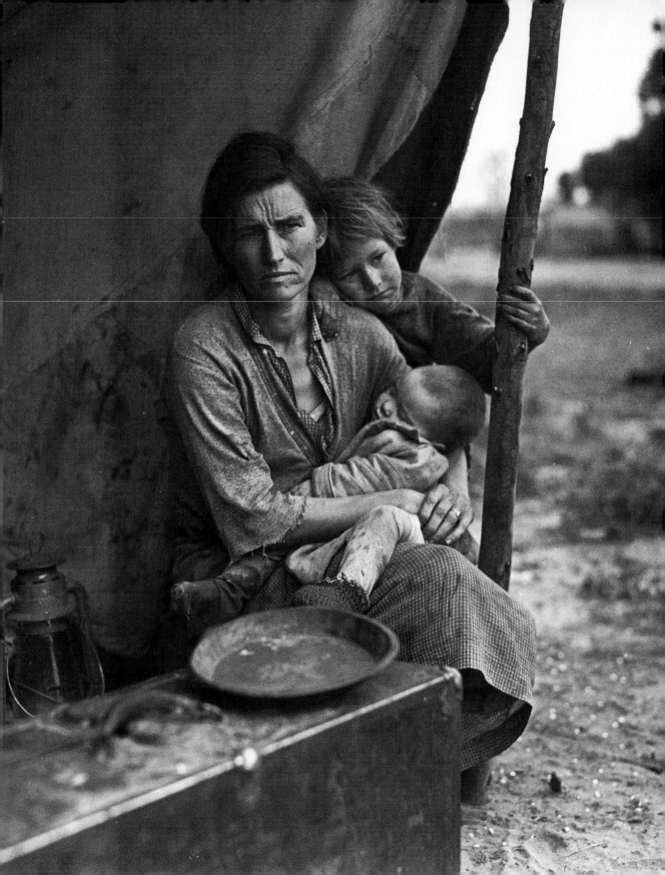

The exhibit was a sensation and brought immediate acclaim to Stryker and the photographers he directed. His choice of the 76 photographs in the display caused controversy, however. The work of Lee and Rothstein made up half of the photos shown. This engendered bitterness among the other photographers, who complained that Stryker rewarded the two more for their loyalty to him than for their work. But, the quality of their work, particularly Rothstein's, speaks for itself (Figure 7.7).

(Opposite)
FIGURE 7.6
MIGRANT MOTHER #4 BY DOROTHEA LANGE, 1936 [GELATIN SILVER PRINT] *[Courtesy of the Library of Congress]*

FIGURE 7.7
DUST BOWL FARM, CIMARRON COUNTY, OKLAHOMA BY ARTHUR ROTHSTEIN, 1936 [GELATIN SILVER PRINT] *[Courtesy of the Library of Congress]*

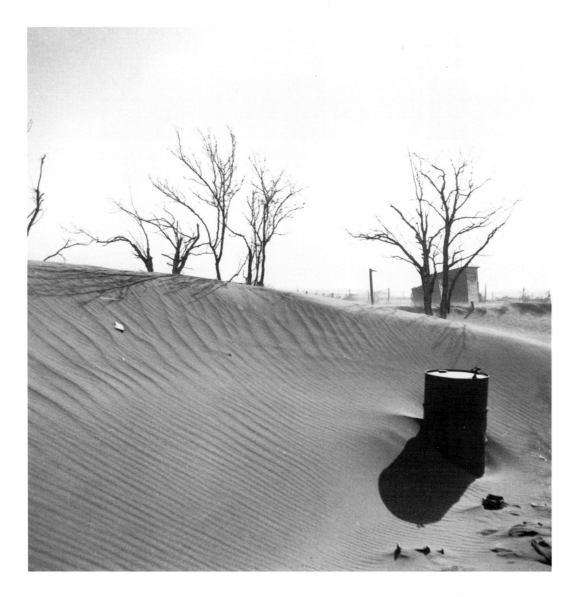

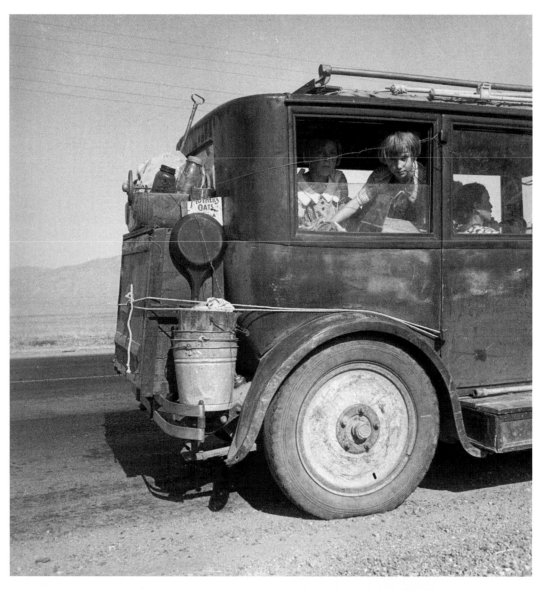

FIGURE 7.8
A MIGRANT FAMILY IN THEIR CAR,
HEADING WEST [GELATIN SILVER
PRINT] *[Courtesy of the Library of Con-
gress]*

TAKING THOUSANDS OF IMAGES

Stryker ignored the criticism and kept his photogra-
phers at work compiling a documentary record of a country's
plight. He hoped to improve conditions by showing people
and their leaders how bad conditions were. By the time the
Office of War Information took over the Historical Section in
1943, the collection contained 270,000 prints. Most still exist
in the files of the Library of Congress.

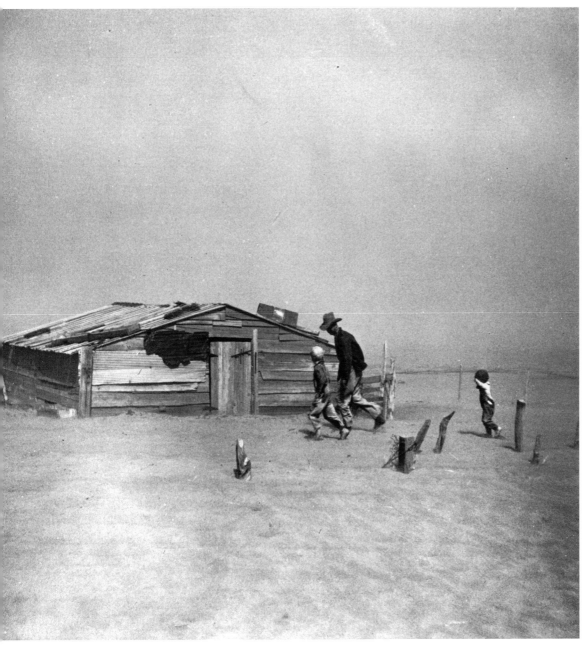

FIGURE 7.9
FLEEING A DUST STORM,
CIMARRON COUNTY, OKLAHOMA
BY ARTHUR ROTHSTEIN, 1936
[GELATIN SILVER PRINT] *[Courtesy of
the Library of Congress]*

"We had a sense that we were in on the beginning of something," wrote Stryker in a later collection of some of the photos. "In 1936 photography, which theretofore had been mostly a matter of landscapes and snapshots and family portraits, was fast being discovered as a serious tool of communication (Figure 7.8), a new way for a thoughtful, creative person to make a statement."

Added Cornell Capa, a photographer and executive director of the International Center of Photography:

> Stryker was a visionary and pioneer. His attitude toward photography can be further summed up as follows:
>
> 1) He believed that photographs can be eloquent because through them one can share the compassionate and often passionate understanding of the photographer.
>
> 2) He believed that photographs can influence and alter people's thinking.
>
> 3) He encouraged the development of the picture essay, a photographic narrative, a story which was more than an accumulation of individual images.

In image after image (Figure 7.9), the FSA photographers brought to life the words John Steinbeck had used in *The Grapes of Wrath* to capture the pain of living in and escaping from the Dust Bowl:

> The dawn came, but no day. In the gray sky a red sun appeared, a dim red circle that gave a little light like dusk; and as that day advanced, the dusk slipped back toward darkness, and the wind cried and whimpered over the fallen corn.
>
> Men and women huddled in their houses, and they tied handkerchiefs over their noses when they went out, and wore goggles to protect their eyes.

As with so many other momentous events of the twentieth century, the lunar landing by an American crew was now certifiably important because Life *said so.*

LIFE AND THE BEGINNING OF PHOTOJOURNALISM

CHAPTER 8

LIFE AND THE BEGINNING OF PHOTOJOURNALISM

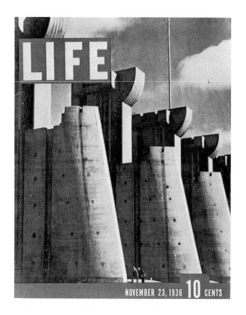

To see life; to see the world, to eyewitness great events; to watch the faces of the poor and the gestures of the proud; to see strange things—machines, armies, multitudes, shadows in the jungle and on the moon; to see man's work—his paintings, towers, and discoveries; to see things thousands of miles away, things hidden behind walls and within rooms, things dangerous to come to; the women that men love and many children; to see and to take pleasure in seeing; to see and be amazed; to see and be instructed.

Thus to see, and to be shown, is now the will and new expectancy of half mankind.

To see, and to show, is the mission now undertaken by Life.

Henry Luce's prospectus for a new picture magazine was a bit lofty and grand for most readers suffering through the hard economic times of the Depression. But when the first press run of 466,000 copies arrived on newsstands November 19, 1936, *Life* sold out immediately. People liked the idea of looking at a magazine that consisted largely of photographs. This was a novel idea in the United States, but not in Europe, where such magazines had been published for years.

PHOTOJOURNALISM IN EUROPE

Photographs had been used to illustrate articles in the newspapers and magazines of Europe as early as the 1890s, primarily because of the introduction of the half-tone technique of screening prints. Along with the *London Illustrated News* and *Paris Moderne,* the *Berliner Illustrierte Zeitung* became the leading publisher of photos, often of people and subjects in the news.

At first, poor page layout and bad quality paper hampered the reproduction of even the best photograph. Gradually, both were improved. Then, developments in camera design and lens capacity further enhanced the emerging field of photojournalism.

In 1923, the German Askar Barnock invented a camera adapted to operate with rolls of cinema film (as explained in Chapter 12). The Leica produced 24 x 36mm images on roll film 35mm wide. The camera went into commercial production in 1924 and was an immediate success. In 1932, its design was improved with the addition of a rangefinder and seven interchangeable lenses of varying focal lengths.

The Rolleiflex, which came out in 1929, was a reflex camera with twin lenses, using a roll of 117mm film and producing images of less than 3 x 3 inches.

Lens design was improving too. The new Zeiss models let in more light, which resulted in faster shutter speeds and clearer definition. Film was improving and becoming more sensitive. Rolls of 36 exposures were handier than the cumbersome plates.

Freed from old technical constraints, photographers began to shoot a variety of subjects, often turning in a whole series on the same topic. When edited and captioned, these photographs were used to tell the story, often without any other text.

In 1928, a man and a camera further shook up the already turbulent world of European photojournalism.

The camera was the Ermanox, which used glass plates or cut film about 1 3/4 x 2 1/4 inches in size. It was fitted with an Ernostar lens with a focal length of four inches. The manufacturer boasted that the camera and lens were revolutionary, because they made previously unknown subjects accessible through the brief exposure required and the camera's ability to use natural light. Before this, photos indoors or at night had been impossible to take without artificial light.

The man was Erich Salomon, a wealthy Berlin lawyer. He did not get interested in photography until 1927 at 42, the year he bought his Ermanox. His connections among the rich and famous of Berlin allowed him to move among them unobtrusively. Salomon took photos of law courts (using a camera hidden in a false bandage) and diplomatic conferences, and of notables like actress Marlene Dietrich (who he photographed when she was talking on the telephone).

In Geneva at a disarmament conference, Salomon dressed in tailcoat and white tie and photographed diplomats while they began debate at 10 pm, then again when they were exhausted and haggard at 1 am. French diplomat Aristide Briand, who befriended the photographer and saw that he got his access, said, at one point: "There are just three things necessary for a League of Nations conference: a few foreign secretaries, a table, and Salomon." When he saw these photos, an English editor found them so different from the usual posed studio portraits that he called them "candid photographs," a phrase that is still used. When viewed by readers,

the photos gave the impression of eavesdropping on the people portrayed, the next best thing to being there. This always has been the secret of the best photojournalism.

After several years, Salomon switched to the Leica, another camera suited to his candid photos. Its roll film was easier for him to use, and it also functioned well in natural light.

Salomon revolutionized photos of politicians and news events involving them. Notes Peter Hunter in an introduction to a collection of the photographer's work:

> Before Salomon entered the arena, photographs of these events were nearly always stiff and posed, devoid of life. The underpaid news photographer, out to get a serviceable shot, usually returned with pictures of rigid diplomats trying to hold a pleasant expression in the midst of an explosive flash of powdered magnesium. . . . Salomon's pictures stood out in startling contrast. They were intimate, unposed views taken when the subjects least expected it . . .

Salomon had great success with his magazine work and his 1931 book, *Famous People Caught Off Guard.* He died in the Auschwitz concentration camp in 1944.

The wide use of photos by Salomon and other photographers to tell stories in German and other European newspapers and magazines had a great influence on Henry Luce and others in his company as they began to plan their new picture magazine.

PRECARIOUS LAUNCH

Luce had been successful in his first two magazine ventures: *Time* (1923) and *Fortune* (1930). That success had given him the necessary funds to start *Life.* The idea for a picture magazine was not originally Luce's. As noted earlier, several European magazines had existed for years. Publishers longed to transplant that concept to the United States, especially to take advantage of the new cameras and film. Luce decided to do something with the concept. He put together the prospectus and invested a great deal of money to hire talented staffers, then to promote and publish the first issue.

As Time's Experimental Department tried to figure out what kind of new magazine to start, Luce got a letter

from Kurt Korff, the former editor of *Berliner Illustrierte Zeitung,* requesting a meeting. The two got along well and Luce hired Korff as a consultant in 1935.

Although his contribution was not acknowledged widely by the company, Korff played a key role in getting *Life* started. According to C. Zoe Smith of Marquette University, the German had a great deal of influence on three levels of recommendations: 1) of the target audience for *Life,* 2) of which photographers should be hired, and 3) of how photographs should be obtained and laid out.

Korff left after a year, feeling exploited by the company. Memos obtained by Smith indicate that the company kept Korff's contributions a secret because it didn't want word of the new magazine to leak prematurely. Luce wanted to be the first to publish a picture magazine in the United States.

Although he had left the company by the time the first issue appeared on newsstands in 1936, Korff's suggestions apparently had been followed.

In a 1935 memo, "Essential Outline for a New Illustrated Magazine," he made these recommendations:

1) *give the magazine a short title*
2) *run only one "very good, thrilling, artistic picture or illustrated article" per issue if quality material cannot be obtained*
3) *feature only one photo essay/article on a particular issue or theme per issue*
4) *spend as much money as necessary to get good material*
5) *publish controversial material as long as it is honest*
6) *obtain exclusive rights to photographs whenever possible*
7) *assign articles on art, theater, literature, and animal life because of their wide appeal*
8) *publish pictures about an upcoming event to arouse interest, followed by exclusive pictures of the event immediately afterward.*

Korff also taught editors in the company how to "read" pictures, showing them the elements that separated great photos from good ones. He showed them how to pull

together and lay out photo essays. The German also produced a dummy of an illustrated magazine to show how single photographs and photo essays could be combined into an effective "package."

Although no one knows precisely why Korff left, Smith says he had not been able to give up his past. The planners of *Life* had no desire to duplicate the *Berliner Illustrierte Zeitung*. Korff was hired as a consultant by newspaper publisher William Randolph Hearst in 1937, and died a month later.

By then *Life* was a year old and doing very well. Ironically, its early success put the whole magazine at risk. Advertising rates were based on a sale of 250,000 copies a week, so each page represented a loss when compared to what it would bring in using actual circulation figures. Added to this factor was the high cost of the heavy coated paper used for good photo reproduction. Because more high cost copies were printed to meet demand than there was advertising revenue to pay for them, *Life* soon was losing $50,000 a week. (Losses reached $6 million before the magazine turned a profit, according to W.A. Swanberg, a Luce biographer.)

The first issue of *Life* (Figure 8.1) set a tone of excellence for what was to follow. The cover photo by Margaret Bourke-White showed the Fort Peck Dam then under construction in Montana by the Works Progress Administration. Also featured in photos were the first aerial shots ever published of Fort Knox and one of the newly opened Oakland Bay Bridge in California. The issue also published shots of the Fort Peck dam builders out on the town on a Saturday night and a startling full-page picture of an obstetrician holding up a newborn baby by its heels with the headline LIFE BEGINS. The issue had quite an effect.

Writes Dora Jane Hamblin in her retrospective look at the magazine, *That Was The Life:*

> *It is difficult to explain, to those too young to remember the first issue, the stunning impact of its size alone. Opened out flat, the magazine measured 13 1/2 by 21 inches, a display space larger than many of today's television screens and in pre-television 1936 a revelation . . .*
>
> *What ensued when* Life *hit newsstands and mailboxes that first week was near-riot. News dealers across the*

nation telephoned and telegraphed for more copies. Presses creaked, groaned, and broke down trying to keep up with the demand . . .

Bourke-White became one of the magazine's first staff photographers. She closed her photo studio to join the staff at a salary of $12,000 a year. Luce's idea fit well with her photographic aims, according to her biographer, Jonathan Silverman. She did encounter some problems, however. She and other photographers had to talk editors into giving photographers credit where their photographs appeared. At first, all credits were listed in a box in an obscure part of the magazine. Eventually, editors and photographers reached a compromise under which credits would appear with photos on layouts of four pages or more.

Another thing that was hard for Bourke-White or any photographer to accept was that editors had the final say about almost everything. Individual photographers had to sacrifice their own wishes in return for having photos seen in *Life* by millions, according to Silverman. "Often the particular sensibility a photographer had brought to a picture assignment was completely distorted by the editors," wrote Silverman in *For The World to See: The Life of Margaret Bourke-White,* "and on occasion such attitudes were the subject of bitter fights between the magazine and photographers such as W. Eugene Smith, who always demanded the right to produce his own layouts."

Bourke-White and Smith soon were joined by an assemblage of photographers unequaled on any magazine before or since: Larry Burrows, Cornell Capa, Robert Capa, Ralph Crane, John Dominis, David Douglas Duncan, Alfred Eisenstaedt, Philippe Halsman, Mark Kauffman, Ralph Morse, Carl Mydans, and Gordon Parks, among others.

Eisenstaedt joined the staff in 1935 as one of four original photographers. Now in his eighties, he still takes photos for the magazine. A product of the German photojournalism tradition, Eisenstaedt was introduced to Luce by his countryman Kurt Korff. His first assignment was to go to Hollywood and do a photo essay on California. He has taken many memorable photos in the years since, his enthusiasm never flagging. "I am crazy about taking pictures," he told an interviewer in 1982.

LIFE'S IMPACT

The impact of *Life* may be hard for present day readers to understand. Now it is commonplace to witness news events as they happen, thanks to instantaneous satellite transmission of images onto television screens. But in 1936, the publication of high quality photos as recently as ten days to two weeks after the events they depicted was just as revolutionary.

Life was everywhere, looking at everything, from the serious to the ridiculous, from the famous to those whose picture in *Life* made them famous. After chronicling the end of the Depression and the beginning of economic recovery, the magazine achieved its greatest success covering World War II, as explained in Chapter 9.

Most of *Life's* photographers gained great distinction for the magazine during World War II. After the war, *Life* continued to prosper by filling its pages with photos and text about the news events of the week. It also published material about great discoveries in medicine and science, history, nature, famous and important people. *Life* had become the world's most popular magazine. Stories were told in stunning photographs by the best photographers, augmented by paintings and illustrations commissioned by the magazine. Readers waited eagerly each week to see how *Life* would cover a big news story. Newspapers would write about the same story, of course, but in the years before television news programs and the instantaneous transmission of satellites, the only way the public could see what happened was to read *Life*.

Life paid a particularly important role in chronicling the early years of the space program. Early on in the initial Mercury stage of the manned spaceflight venture, the magazine signed an exclusive contract with the first group of astronauts agreeing to publish their descriptions of the flights. Their words were augmented by stunning color photographs taken in outer space.

On July 20, 1969, Neil Armstrong, Edwin Aldrin, and Michael Collins reached the moon. The photos they took of their activities, including one of Aldrin with Armstrong reflected in his visor (Figure 8.2), appeared in a subsequent issue of *Life,* along with their descriptions of the journey.

As with so many other momentous events of the twentieth century, the lunar landing by an American crew was now certifiably important because *Life* said so.

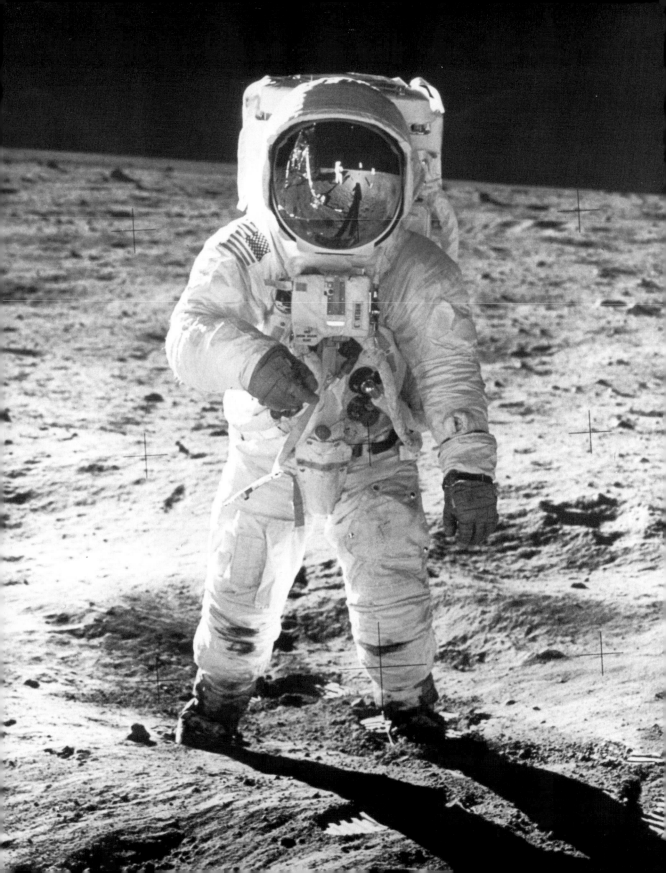

Continues Hamblin: "The man from *Life* became fairly well known over the course of 36 years, to virtually every head of state in the world; all the best quarterbacks and movie stars; the most famous crooks, in or out of jail; astronauts and scientists; politicians, painters, and preachers . . . and thousands of ordinary citizens whose chief claim to fame was that (a) once they appeared in *Life* or (b) they didn't appear after having knocked themselves out to cooperate with the photographer."

(Opposite)
FIGURE 8.2
ASTRONAUT EDWIN E. ALDRIN, JR. WALKING NEAR THE LUNAR MODULE ON THE MOON; ASTRONAUT NEIL A. ARMSTRONG REFLECTED IN HIS VISOR, JULY 20, 1969
[Photo courtesy of the National Aeronautics and Space Administration]

THE END OF THE LINE

Nevertheless, time began to run out for *Life* in the late 1960s. Reluctantly, *Life's* editors and photographers came to realize that even with later deadline closings than in the past, they could not compete with television news. Another problem arose as well. Even as the magazine increased its circulation to a high of 8.6 million in 1970, *Life* had to face the high costs of printing and mailing all the copies at a time when advertising pages were declining. The expense of sending photographers and writers all over the world was prohibitive as well.

It is a fact of journalistic life that a publication cannot prosper on circulation alone. It costs a great deal of money to print and mail each issue and more money still to seek new subscribers to replace those who do not renew. At the point of its highest circulation, *Life* subscribers were paying as little as 14 cents a copy to receive it. Even though *Life* officials cut circulation later and increased the price, it was too late. Postage increases of as much as 170 percent in 1970 only added to the problem.

Advertisers discovered that they could reach a mass audience with information about their products via television. *Life's* advertising revenues peaked in 1966, when the magazine sold 3,300 pages of ads for nearly $170 million.

The December 29, 1972 issue was the last for *Life.* In its last four years, the magazine lost $30 million. It returned as a monthly in 1978 but only as a shadow of its former self, a great, grand American journalistic institution whose equal never will be seen again.

To photographers, *Life* represented the first large-scale market for photojournalism. Indeed, *Life,* strongly influenced by several European picture magazines, invented

photojournalism in the United States. From its first issue, *Life* put photographs before text and, for the most part, photographers before writers. Photographers may have had to argue constantly with editors over photo size and placement and even the wording of captions, but they reigned supreme. The magazine could not have been what it was without them. The power and influence of photojournalism has extended to this day to other magazines, newspapers, and television networks. One picture is truly worth a thousand words, and *Life* started the trend.

Nowhere were those who snapped pictures as supreme as on the staff of *Life*. As Hamblin put it in her memoir, the dominant force at the magazine truly was "God the photographer."

PHOTOGRAPHY GOES TO WAR, AGAIN (AND AGAIN)

The war was a heady time for photographers. They proved they could provide an unmatched record of great events, whether in the conference rooms where statesmen and generals made important decisions or in the thick of battle.

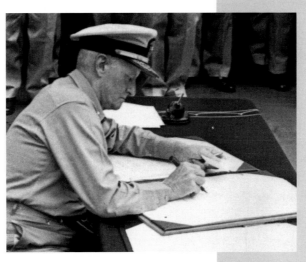

PHOTOGRAPHY GOES TO WAR, AGAIN (AND AGAIN)

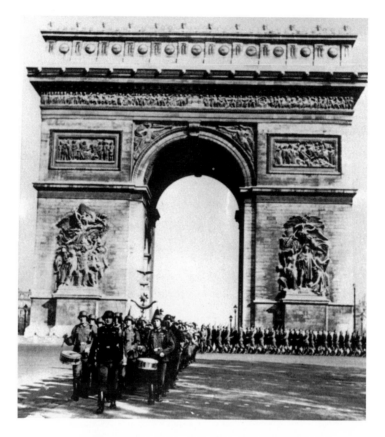

FIGURE 9.1
GERMANS ENTERING PARIS BY MAURITIUS, 1940 *[Courtesy of Black Star. Published with permission]*

Press coverage of World War II began even before war was declared. In the period up to the German invasion of Poland on September 3, 1939, the managers of various news organizations in the United States and in Europe started preparing for what they knew was inevitable: a war of a scope not seen before, possibly on two fronts.

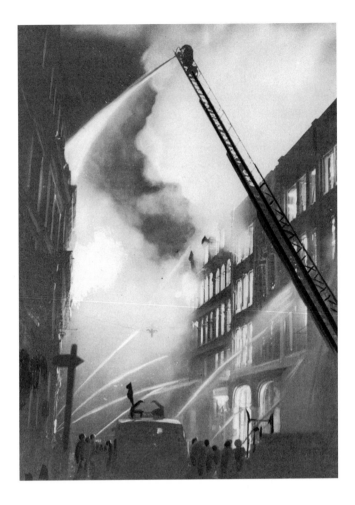

These news organizations hired reporters, editors, and still and newsreel photographers. In time, there would be more than 500 full-time American correspondents abroad at one time or another. Included in their ranks were photographers, both military and news. The more traditional newspaper photographers had new companions: a number of men and women who worked for *Life* and the other new picture magazines. As noted in Chapter 8, *Life* placed a special emphasis on war coverage from 1939 on.

With so many photographers covering the war, most major events were captured on film: the German Army entering Paris (Figure 9.1), and the bombing of London, which began in September, 1940 (Figure 9.2)—when an average of 200 German bombers attacked the city each night.

Newsreel photographers were equally important. Before television, people relied on newsreels shown in theaters to see an event after reading about it and looking at still shots in newspapers and magazines. "The March of Time," Fox Movietone News, and other organizations sent a number of camera teams into the middle of all war action.

The official government photographer had a more important role than today, during peace or war. In the period up to the United States' entry into the war after the Japanese attack on Pearl Harbor (Figure 9.3) on December 7, 1941, the American government was neutral. As a result, the two major belligerents in Europe—Great Britain and Germany—went to

FIGURE 9.3
JAPANESE ATTACK ON PEARL HARBOR, USS ARIZONA BURNING BY A U.S. NAVY PHOTOGRAPHER, 1941 *[Courtesy: National Archives and Naval Historical Society]*

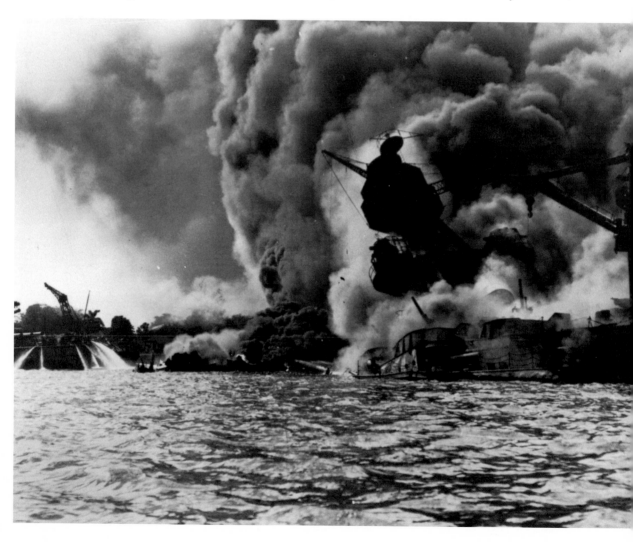

a great deal of trouble to convince Americans and their government of the rightness of their respective positions.

PHOTOS AS PROPAGANDA

Germany had learned how to manage the news from Britain in World War I. It set up a Ministry of Propaganda under Joseph Goebbels to influence correspondents based in Berlin who were from neutral countries. Its Foreign Press Department took care of their personal needs and the logistics of moving them to the action. Very quickly as many as 100 men and women had moved to Berlin and were working as accredited correspondents. The few photographers among them had special difficulties—as photographers always do—because authorities often feared they would take shots of military installations. They restricted photographers' access and monitored their movements.

Goebbels pressed German writers and photographers into service for his government in an effort to tell the German story. Their main aim, he told them, was to "influence the course of the war by psychological control of the mood at home, abroad, at the Front, and in enemy territory."

At first, their efforts were highly successful. In the early stages of the invasion of Poland, neutral correspondents in Berlin were given photographs, reports, and newsreel footage of events. Later, a few correspondents were permitted to accompany the German army. Their purpose was to back up what German officials were telling them with their own reports. Soon, German newsreels flooded movie theaters all across the United States. American newspapers also regularly printed photographs furnished by the German government.

The British were outraged at this one-sided treatment. The Ministry of Information was the target of a great deal of criticism because of its slowness to tell the British side of the story, according to Phillip Knightley in *The First Casualty*. By October 10, 1939, the government had brought fifteen British and Commonwealth correspondents, nine Americans, and eight press and newsreel photographers to accompany their forces in France. Their movements were tightly restricted, however, which led to a great deal of criticism by the reporters.

Continued on page 115.

Focus: Photography in World War I

Although cameras were smaller and could take pictures instantaneously by the time World War I began in 1914, photography and attitudes toward its publication meant it still was not able to cover the conflict on the scale possible in World War II. "Action reporting in any quantity had to wait for the technical invention of the 35mm camera, introduced in the late 1920s, and the development of the recognized profession of photojournalist," writes Colin Ford in his introduction to Jane Carmichael's *First World War Photographers*.

Nevertheless, a considerable number of photos were taken, 40,000 by British government photographers alone. News photographers and amateurs were at work as well.

As would happen in World War II, official photographers had more access than news photographers, who found their movements severely restricted. They almost were completely excluded from the Western Front, but were allowed into Egypt and Mesopotamia.

Beginning with World War I, servicemen took their own cameras to war and their photos offer an interesting, unofficial, unprofessional view.

"The photographs of the First World War offer an extraordinary range of images," writes Carmichael. "With their origins established, they can be appreciated not only for their documentation of one of the great conflicts of the twentieth century but also for the insights they offer into the operations of propaganda and journalism during a period and for the sum of their individual achievements."

Even great photos like that taken at the Battle of the Somme on July 1, 1916 (Figure 9.4), however, had to be accompanied by detailed captions. Photographs never replaced the written word, according to Carmichael. Photographers were thus relegated to a position well below that of corespondents, a status that would change during World War II.

JOINING THE ARMIES

Once the United States entered the war in 1941, criticism against Allied governments ended. There was no doubt in the mind of any reporter or photographer about who the enemies were: Germany, Italy, and Japan. The press worked primarily by following the various Allied armies as they moved to stop German armies in Europe and Japanese armies in the Pacific. In addition to recording battles and invasions, photographers such as W. Eugene Smith photographed individual soldiers (Figure 9.5). Altogether, the U.S. armed forces accredited 1,646 different reporters and photographers in the years of the war. The press associations such as Associated Press and United Press and the three radio networks fielded the largest staffs, as did major newspapers such as *The New York Times*, the *New York Herald-Tribune*, the *Chicago Tribune*, *Chicago Daily News*, *Chicago Sun*, the *Christian Science Monitor*,

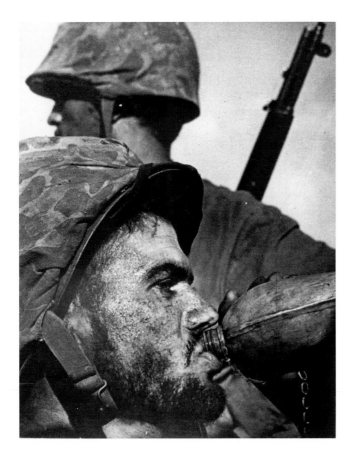

FIGURE 9.5
MARINES UNDER FIRE BY
W. EUGENE SMITH, 1943
[GELATIN SILVER PRINT]
[©1943 W. Eugene Smith.
Published with permission]

the *Baltimore Sun,* and such magazines as *Time, Life,* and *Newsweek.*

In all the thousands of photographs taken and published during the six years of World War II, several individual efforts are worthy of special mention.

The New York Times mobilized its considerable resources to cover the invasion of France on D-Day June 6, 1944. Photographers and reporters waded ashore with Allied armies. Photographic coverage exceeded anything ever printed in the *Times,* according to Meyer Berger in *The Story of* The New York Times. Although past *Times* policy had decreed a minimum of photos, the publisher decided it was time for a change. "He had called for more and more photo coverage," wrote Berger. "It had become a picture age. The *Times* had to keep step with it."

In April 1945, the *Times* also published exclusive photos of the corpse of Italian dictator Benito Mussolini after he had been hanged by his ankles by the partisans who killed him.

Berger picks up the story:

> *It was 11:30 p.m. when the radio photo-receiving drum in Press Wireless began to hum, picking up the print images as they came across the Atlantic. Dugen [of the photo department] was fascinated as they took shape. They were sharp and clear in photographic detail. At 11:45 they were in the* Times *photo darkroom for printing.*
>
> *One print showed Mussolini lying side by side with Clara Petacci at the feet of grim-visaged partisan riflemen. McCaw [an editor] captioned it, "Inglorious End of a Dictator," and marked it for four columns on Page 1 . . .*

RAISING THE FLAG OVER IWO JIMA

Another memorable photo emerged from the hundreds of thousands of images taken in World War II. In February 23, 1945, a group of U.S. Marines raised the American flag on Mount Suribachi on the tiny island of Iwo Jima. When they did so, Joe Rosenthal, an Associated Press photographer, was there to record it for posterity (Figure 9.6).

Rosenthal had landed on Iwo Jima on February 19 with other reporters and photographers. In eleven days on

the island, he used his Speed Graphic and Rolleiflex cameras to take 65 pictures. He took the shot of the flag raising soon after two patrols fought their way to the top of the Japanese observation post on Suribachi.

The first Marines had hoisted a small flag before Rosenthal got there. Those in the contingent he was with decided to raise another so it could be seen on other islands and on ships offshore.

Recalled Rosenthal in an interview published in *Pictures on a Page* by Harold Evans:

> "... I backed off about 35 feet. Here the ground sloped down towards the center of the volcanic crater and I found scrub was in my way. I shoved some stones and Japanese sandbags on top to try to raise myself about two feet (Rosenthal is only 5 ft. 5 in.) I decided on a lens setting between f8 and f11 and set the speed at 1/400 ... "

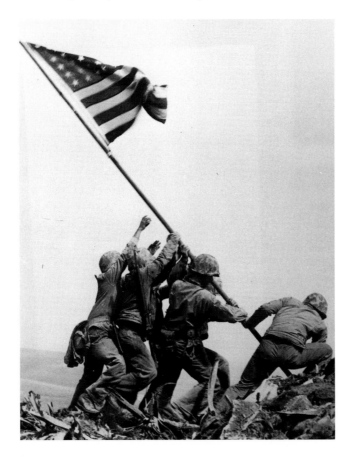

FIGURE 9.6
OLD GLORY GOES UP ON MT. SURIBACHI, IWO JIMA BY JOE ROSENTHAL, 1945
[Published with permission. AP/Wide World Photos]

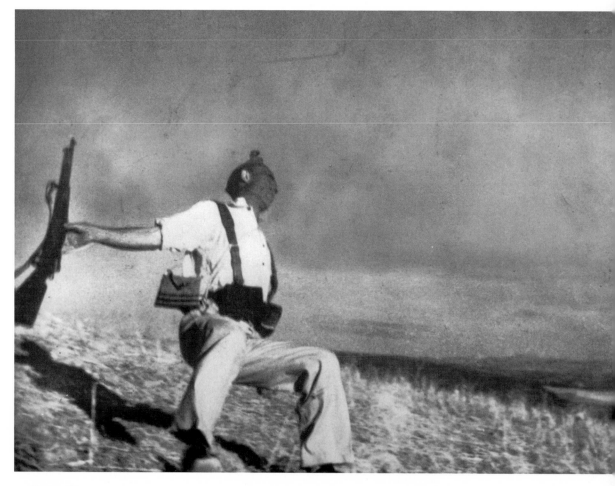

FIGURE 9.7
DEATH OF A LOYALIST SOLDIER
BY ROBERT CAPA, 1936
[GELATIN SILVER PRINT]
[©1936 Robert Capa and Magnum
Photos, Inc. Published with permission]

Rosenthal was not sure he had gotten a picture, according to Evans, until the film was developed at press headquarters in Guam and the photographer started getting congratulated. "When you take a picture like that," said Rosenthal, "you don't come away saying you got a great shot. You don't know . . . "

No photographers working individually or for a publication performed better during World War II than the men and women working for *Life*. Publisher Henry Luce had decided in 1939 to expand some of his considerable fortune on war coverage. As always with *Life*, it was the photographers who got the emphasis—both on resources to send them to even far-flung theaters of the war and on space devoted to the photographs they sent back.

BOURKE-WHITE AND CAPA

One *Life* photographer, Margaret Bourke-White, realized her wish to photograph the war in 1941 when she traveled to the Soviet Union via China. In Moscow on July 15, she recorded the first German air raid from her hotel balcony.

"The first of several bombs that fell had one practical result," wrote Bourke-White. "It brought everybody out of bed. All the doors down the length of the hallway opened simultaneously, as though pulled by a single string, and correspondents came plunging out on their hands and knees in various stages of scanty attire . . . I was dressed, fortunately, and I snatched up my camera and ran out into the street. The air reeked with the smell of cordite . . ." She continued to cover the war and was present when Allied soldiers liberated the Nazi death camps in 1945.

Another photographer who gained fame during World War II was Robert Capa. Several years before, Capa had taken a shot of a man at the moment of his death in the Spanish Civil War (Figure 9.7). Readers had protested *Life's* publication of it, saying the picture was too brutal. Capa covered the war for *Life* from the Japanese invasion of China in 1938 to a number of events in the next few years: the North African campaign, the Italian invasion, the Normandy invasion, and the liberation of Paris. "When you're in the fighting, you don't go where there's fire, you go where there are pictures," he told Army combat photographers preparing for the D-Day invasion.

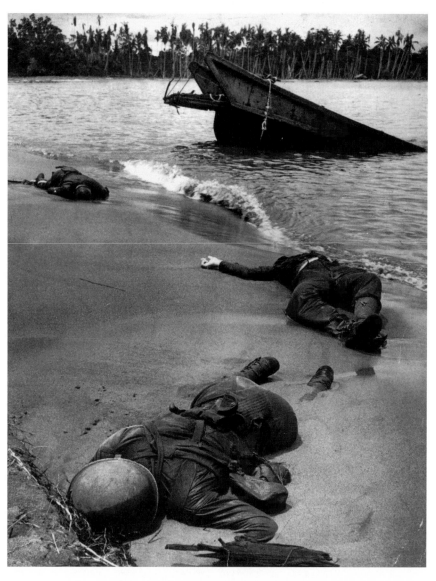

One of the magazine's most controversial photos also appeared during the war. George Strock's 1943 view of a dead American soldier face down in the sand in New Guinea brought the war home to readers (Figure 9.8). The War Department withheld approval to publish for days and many readers protested when the photo appeared.

The war was a heady time for photographers. They proved they could provide an unmatched record of great events, whether in the conference rooms where statesmen

and generals made important decisions or in the thick of battle. Just as they had been in on the war's beginning in 1939, photographers were there when it ended, at the signing of the Japanese surrender on September 2, 1945 (Figure 9.9).

Among the 37 American correspondents killed during World War II were four photographers. This fatality rate typifies the new place of photographers during the war: at the center of action recording everything before the camera's eye with unflinching courage and dedication.

FIGURE 9.9
ADMIRAL CHESTER NIMITZ SIGNS THE INSTRUMENT OF SURRENDER ON THE USS MISSOURI AS GENERAL DOUGLAS MACARTHUR (LEFT) AND OTHER OFFICERS LOOK ON BY A U.S. NAVY PHOTOGRAPHER, 1945
[Courtesy: National Archives and the Naval Historical Foundation]

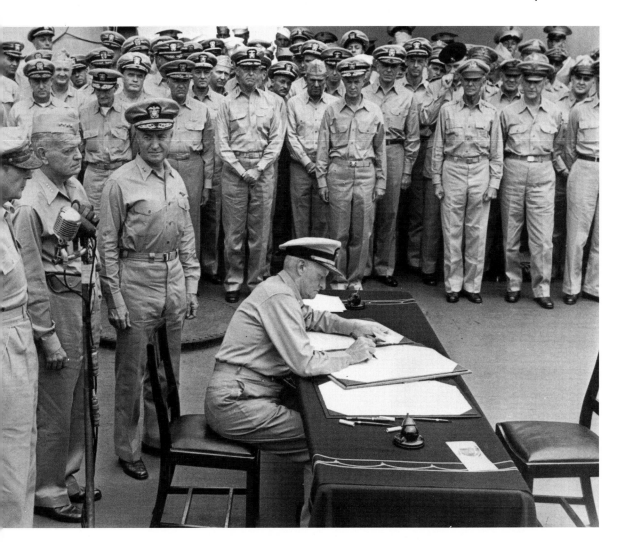

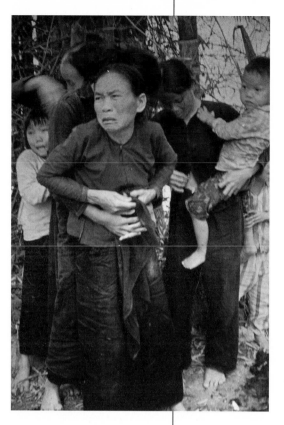

Focus:

Photography

in the

Vietnam War

I n the Vietnam War, the photographer's status was even higher than in World War II. Both staff and freelance still and television photographers had special access seen in no other conflict before or since. They and the reporters who followed them could go virtually anywhere and shoot anything. They simply hitched rides on departing helicopters and followed armies into battle without interference, returning to their hotels each night.

The U.S. government decided to intervene in the war in Indochina in August 1964 after an incident involving an alleged attack on two U.S. ships in the Gulf of Tonkin. The war escalated quickly. There were more than 160,000 troops in Vietnam by the end of 1965.

Wanting to be where the news was, all major news organizations sent great numbers of staff members and freelancers to Vietnam. So much war news appeared on television that Vietnam soon came to be known as "the living room war."

As always, controversy dogged some war photos. The most sensational image appeared on television, not in a still photo. In August 1965, Morley Safer of CBS News and two Vietnamese cameramen shot "The Burning of the Village of Cam Ne." A Marine was seen setting the roof of a hut on fire with a cigarette lighter. That, together with views of terrified peasants and dead bodies, was too much for many viewers who complained bitterly to CBS and the government.

Another memorable, grisly image was taken by *Life* photographer Ron Haeberle at the village of My Lai on March 16, 1968. A platoon led by 2nd Lt. William Calley killed 347 people suspected of being Viet Cong sympathizers. Their bodies were still in a ditch when photographers arrived, and surviving villagers looked on in terror (Figure 9.10).

The photo seemed to capture what the war had been about: slaughter with little purpose.

WOMEN AS PHOTOGRAPHERS

In pictorialism, the photographer's camera replaced the painter's brush to record scenes that were artistic instead of realistic. Women were especially prominent in this early photography movement.

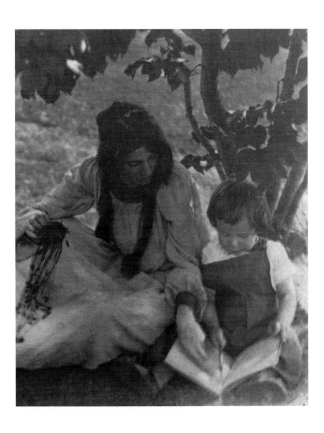

WOMEN AS PHOTOGRAPHERS

Women first were attracted to photography as a profession in the late 1880s. During this period, photography magazines were recommending photography as a suitable occupation for women, according to photo historian Naomi Rosenblum. The newly organized Federation of Women Photographers urged the same thing. In addition, various competitions for female photographers were being set up.

Compared to more established arts such as painting and sculpture, photography did not require training in male-dominated academies, long periods of apprenticeship, or large time commitments in which to practice, according to Rosenblum. Photographers could aim the camera at a subject and see what emerged in the final print.

Julia Margaret Cameron, one of the earliest female photographers, began her career in 1863 when her daughter gave her a camera. She specialized in portraits (Figure 10.1) and allegorical subjects. Despite her success in photographing the rich and famous, Cameron never considered herself a professional and seldom accepted money for her work.

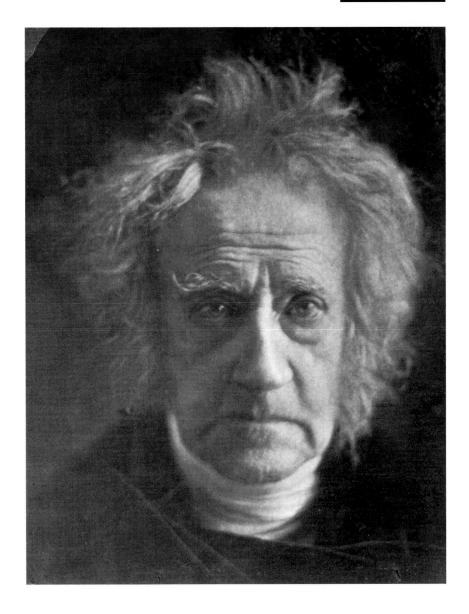

THREE CLASSIFICATIONS

Female photographers in this early period can be placed in three categories: social documentarians, pictorialists, and photojournalists.

Two women who fit the first category were Chansonetta Stanley Emmons and Alice Austin. Emmons concentrated her work around the small town of Marlborough, New

FIGURE 10.1
SIR JOHN HERSCHEL BY JULIA
MARGARET CAMERON, 1867
*[Gift of Mrs. J.D. Cameron Bradley.
Courtesy, Museum of Fine Arts, Boston]*

Hampshire, where she recorded everyday life in 1900. Austin's focus was entirely different: the teeming neighborhoods of lower Manhattan from 1895 to 1900 (Figure 10.2).

In pictorialism, the photographer's camera replaced the painter's brush to record scenes that were artistic instead of realistic. Women were especially prominent in this early photography movement. Among them were Gertrude Kasebier (Figure 10.3), Mary Devens, Emma Farnsworth, Clara Sipprell, and Eva Watson-Schutze, all of whom specialized in taking portraits at the turn of the twentieth century. In the period up to World War I, Anne W. Brigman, Adelaide Hanscom Leeson, and Janet Reece concentrated on nudes. Still other women specialized in photojournalism, for example, Frances Benjamin Johnston. In 1900, she arranged an exhibit of 142 photos by 28 women and mounted it in France and Russia.

FIGURE 10.2
"HESTER STREET EGG STAND"
BY ALICE AUSTIN, 1895 [GELATIN
SILVER PRINT] [Courtesy of the Staten
Island Historical Society]

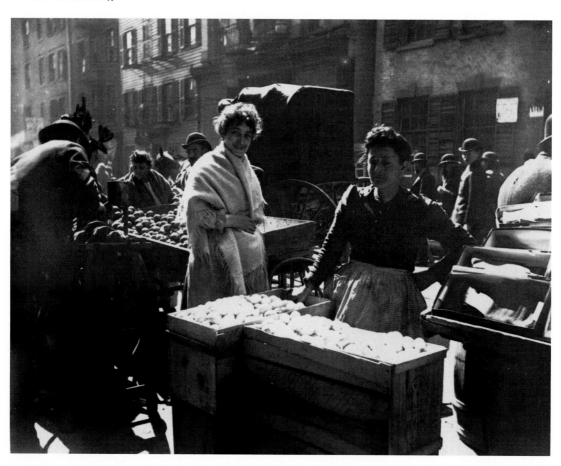

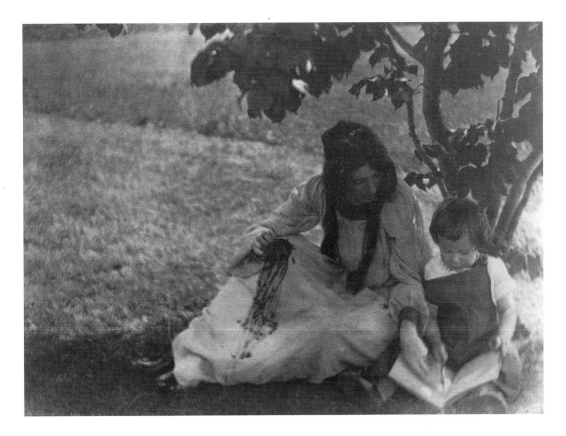

Immediately after World War I, photography had three different thrusts: art, commercial/industrial, and documentary/photojournalism. All three segments included women among their most eminent practitioners.

CUNNINGHAM, LANGE, BOURKE-WHITE

Foremost among the art photographers was Imogen Cunningham (Figure 10.4). She was part of the "f/64" group of San Franciscans who advocated what became "precisionism," beginning in 1930. These photographers, including Ansel Adams and Edward Weston, used large-format cameras, small lens apertures, and printing by contact instead of enlarging, according to Rosenblum. Cunningham was particularly successful with nude studies in which the human torso became lines and unusual angles. She was influential long after she quit taking photographs. Cunningham died in 1976.

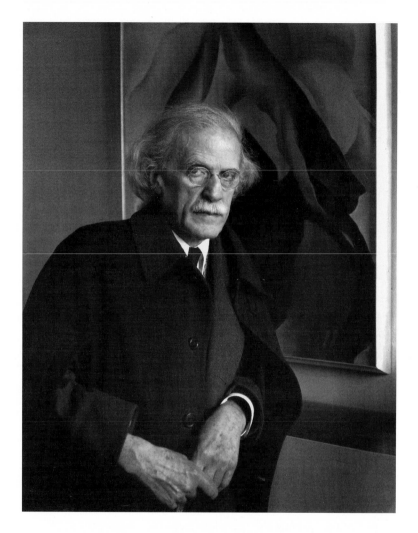

Chapter 7 discussed the documentary work of Dorothea Lange. The photojournalism of Margaret Bourke-White was the subject of Chapter 8. Less known is the early commercial work of both women—Bourke-White in industry shots, Lange as a portrait photographer.

Bourke-White began her career as a photographer of a variety of industrial scenes and products: automobiles, watches, paper mills, buildings, steam engines, steel mills. "There is something dynamic about the rush of flowing metal, the dying sparks, the clouds of smoke, the heat, the traveling cranes clanging back and forth," she said. Her first industrial assignment was to photograph the Otis Steel Mill

in Cleveland, Ohio in 1928. Steel-making had never been captured in quite the same dramatic way. Soon, Bourke-White was making a good living taking photographs of steel mills, according to her biographer, Jonathan Silverman. Her work attracted the attention of Henry Luce, founder and owner of *Time* and of *Fortune,* a new magazine he was planning with business as its subject. He bought a series of her steel photos to appear in *Fortune's* first issue in February 1930. He quickly hired her to work half-time for *Fortune* at the high salary of $1,000 a month.

Her arrangement with Luce enabled her to do her own free-lance photography the rest of the time. She moved

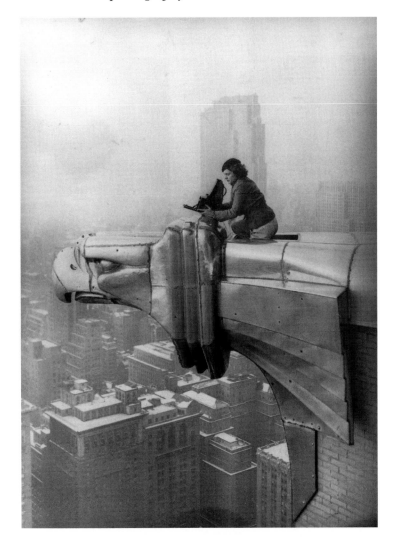

FIGURE 10.5
SELF-PORTRAIT OF MARGARET BOURKE-WHITE OUTSIDE HER CHRYSLER BUILDING STUDIO BY MARGARET BOURKE-WHITE, 1930
[Courtesy Margaret Bourke-White Estate. Published with permission]

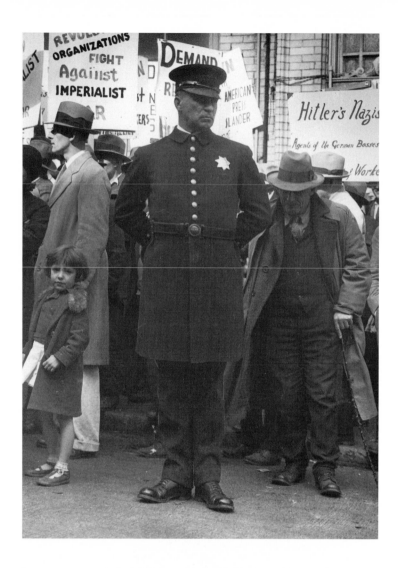

her commercial studio to New York from Cleveland and rented space in the newly opened Chrysler Building (Figure 10.5). Later in her career, Bourke-White concentrated almost exclusively on photojournalism after joining the staff of *Life* full-time.

Dorothea Lange got her first formal training in a photo seminar at Columbia University in New York. Her first job was in the photo-finishing department of a dry-goods store in San Francisco in 1918. She joined the San Francisco Camera Club so she could have access to a darkroom. At the club she met, among others, Imogen Cunningham, who

encouraged her to open her own studio. During the 1920s, Lange began to develop her artistic instincts. After some experimentation with plants and landscapes as subjects, Lange decided she wanted to concentrate on people—"only people, all kinds of people, people who paid me and people who didn't," she said.

In 1933, Lange became caught up in the Depression and the effects it was having on the world around her. As the Depression worsened, fewer and fewer of her formerly wealthy families could afford to hire her to take portraits. As a result, Lange had more time to leave her studio to take photos of bread lines, picket lines, strikes (Figure 10.6), people on relief, and the homeless. She caught her subjects up close or in unusual views: a woman's stocking with a run or a man's worn-out shoe, for example.

"With the possible exception of Lewis Hine and Jacob Riis, who made studies of workers and slum conditions in New York in the 1890s and early 1900s, there were no precedents in America for the kind of photographs Lange now started to make," writes Christopher Cox in his book *Dorothea Lange*. "She instinctively joined a cultural movement to reveal the impact of economic and social changes in the lives of the American people. New forms of realistic expression in art and literature, film and photography were emerging—with Lange in its vanguard of documentary in the 1930's."

It was this starkly real view of life that attracted Roy Stryker and caused him to invite Lange to become a photographer for the Farm Security Administration.

TWO OVERLOOKED PHOTOGRAPHERS

Another woman was a part of that project too. Marion Post Wolcott was a free-lance photographer for the Associated Press and *Fortune* and a staff photographer for the *Philadelphia Evening Bulletin,* the only woman in America filling such a position. Stryker hired her in 1938 as his third employee.

On her first trip to the coal mining region of West Virginia, she carried a hatchet in her luggage for protection. She had most of her success in her informal portraits of the very young and the very old. She also did beautiful landscapes.

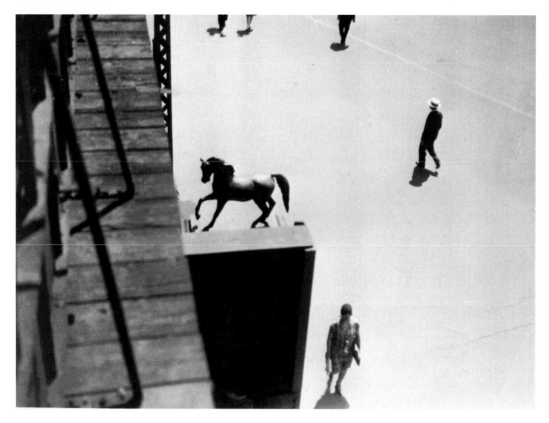

FIGURE 10.7
EL AT COLUMBUS AND BROADWAY, NEW YORK CITY BY BERENICE ABBOTT, 1929 [GELATIN SILVER PRINT, 16.5 X 22.4 CM, JULIEN LEVY COLLECTION, GIFT OF JEAN LEVY AND THE ESTATE OF JULIEN LEVY, 1988.157.1] *[Photograph courtesy of The Art Institute of Chicago.]*

Berenice Abbott also took documentary style photographs during the Depression for a federal agency (Figure 10.7). The Federal Arts Project and the Works Progress Administration sponsored her series of unusual photographs of New York City during the 1930s. She had worked in Paris earlier in her career as technical assistant to abstract photographer Man Ray. While there, her style was influenced by the haunting scenes of the city recorded on film by Eugene Atget.

In recent years, Diane Arbus gained fame with her photos of ordinary people in unique and often bizarre circumstances, from unusual angles. She died in 1971 just as her career was beginning. Her suicide was almost foretold by her depressing images.

COMMERCIAL PHOTOGRAPHY

In the last half of the nineteenth century, photographers realized that people wanted images of themselves and would pay to get them.

COMMERCIAL
PHOTOGRAPHY

FIGURE 11.1
HESTER McDOWELL
BY WILLIAM M. OAKS, 1895
[Published with permission of Verna M. Lovell]

N o look at photography's rich history would be complete without an examination of the prosaic, yet vital, field of commercial photography. While the more famous photographers mentioned in these pages were shooting great events and photographing people and things artistically, a larger group was making a living doing studio, industrial, and advertising work, often of excellent quality.

STUDIO PHOTOGRAPHERS

In the last half of the nineteenth century, photographers realized that people wanted images of themselves and would pay to get them. Although the first subjects caught in the camera's lens were notable people, contrived heroic or historical events, or still life scenes, "real people" eventually were being shown in photos, first in daguerreotypes and later by more modern techniques.

In a typical situation, a photographer would open a studio in a town and take portraits of the men, women, and children who came in the door. The studio was a windowless room containing a plain backdrop. The photographer would use various props to augment the scene: chairs, pillars, drapes, books.

The results often were good, clear photos certain to satisfy people unaccustomed to seeing photos of themselves. Photographers took a whole range of subjects: from individual portraits (Figures 11.1 and 11.2) to married couples (Figure 11.3) to children (Figures 11.4 and 11.5) to class (Figure 11.6)

and graduation photos (Figure 11.7). The photos gave families a way to secure images of themselves for posterity—and their family albums. In some cases, it was possible to record a family in its youth (Figure 11.8) and in later years (Figure 11.9) with interesting results.

Even in small towns, and certainly in large cities, studio photographers could make a comfortable living. Indeed, photographers who had greater ambitions for themselves often started their careers as studio photographers, or earned money to pursue artistic dreams by taking shots of people and their children.

Edward S. Curtis, the chronicler of the American Indian described in Chapter 5, bought a share of a Seattle photography studio from a friend in 1891 for $150. A year later, he changed partners and began to seek work taking

(Opposite)
FIGURE 11.2
WILLIAM F. MCDOWELL BY WILLIAM M. OAKS, 1895 *[Published with permission of Verna M. Lovell]*

FIGURE 11.3
JOHN AND JANE BICKERTON
[Published with permission of Verna M. Lovell]

(Opposite)
FIGURE 11.4
LORA McDOWELL BY WILLIAM M.
OAKS [Published with permission of
Verna M. Lovell]

FIGURE 11.5
VERNA AND WILLIAM BICKERTON
BY CLARK'S STUDIO, 1920 [Published with permission of Verna M.
Lovell]

portraits and engraving plates for reproduction in books, magazines, and business publications.

Curtis and his partner, Thomas Guptill, prospered and soon were established as what one photo magazine called "the leading photographers on Puget Sound." Their work, it said, "could be found in nearly every home in the Northwest." In 1896, the two won a bronze medal from the

FIGURE 11.6
STUDENTS IN GRADE B2, JOHN
MUIR SCHOOL, SANTA MONICA,
CALIFORNIA, 1944 *[Published with
permission of Verna M. Lovell]*

National Photographers Convention in Chautauqua, New York for excellence in posing, lighting, and tone. The 101 images they submitted all were of Seattle citizens taken the previous year.

Dorothea Lange began her career in the photo finishing department of a dry goods store in San Francisco. Through friends, she met a wealthy young man who offered to finance her own portrait studio. After she opened the studio a year later, her work achieved immediate success. Before long, she had become the favorite photographer of many wealthy families in the Bay Area.

Lange's photos depicted important family events. "In the studio, she usually kept a respectful distance from the subject," writes Christopher Cox in a book on her work. "But when she took her camera into their homes, her work exhibited more spontaneity. She followed children into backyards and posed family members against blossoming trees, hanging vines, or sun-lashed walls."

She continued her studio work into the 1930s, although the Depression drastically reduced the number of customers with the money to have portraits taken. She turned to documentary work and joined the FSA photography group in 1935, as noted in Chapter 7.

During this same period, another famous photographer was beginning his career by working in the studio. Ansel Adams opened a commercial photography studio in 1930 to support both his family and his creative work.

"Over the years of the Great Depression," he wrote in his autobiography, "I did everything from catalogs to industrial reports, architecture to portraiture. Our bank account would dwindle to a distressing level and I would grow deeply concerned, then, usually at the financial brink, with creditors gathering, the phone would ring and an assignment would present itself."

The photographer brought the same skill to his commercial work as he did to his nature scenes. Whether the view was through a bakery window or of glassware on a dressing gown for advertisements, the photos were crisp and eye-catching and always taken from unusual angles. Adams continued to do commercial work until the 1970s.

INDUSTRIAL PHOTOGRAPHERS

The rise of large industrial companies in the United States and Europe early in the nineteenth century coincided with improvements in photography and an increase in the number of photographers able to meet the often demanding requirements of this segment of the profession.

In this kind of photography, clarity and precision are everything. The artistry is not in the unusual camera angle or the bizarre reproduction technique.

Industrial photographers always have taken photographs that will be useful to the viewer: in a manual to tell them how to do something, in a brochure to let them decide whether to buy a product, in a report to detail the results of

(Opposite, top)
FIGURE 11.8
THE WILLIAM F. MCDOWELL FAMILY BY WILLIAM M. OAKS, 1905 [Published with permission of Verna M. Lovell]

(Opposite, bottom)
FIGURE 11.9
THE WILLIAM F. MCDOWELL FAMILY BY CLARK'S STUDIO, 1935 [Published with permission of Verna M. Lovell]

FIGURE 11.10
RAYMOND DE MOSS AND THE STAFF OF THE SANITARY BAKERY, CORVALLIS, OREGON BY BALL STUDIOS, 1920 [Courtesy of Fred C. Zwahlen, Jr.]

James Potter,
Leather - Breeches Maker.

At the Sign of the Boot *and* Breeches, *within Three Doors of Aldgate, on the Left Hand Side of the Way, in* Shoemaker-Row.

MAketh and Selleth all Sorts of Leather-Breeches, by Whole-fale and Retail, at Reafonable Rates.
Likewife Buck and Doe Skins and all Sorts of Leather for Breeches.

Printed at the Old Katherine-Wheel without Bifhopfgate

FIGURE 11.11
18TH CENTURY HANDBILL

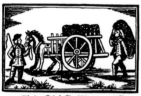

AT *the* Old Collier *and* Cart, *at* Fleet-Ditch, *near* Hol-born-Bridge, *Are good Coals, Deals, Wainfcote and Beach,* &c. *fold at reafonable Rates, by*
John Edwards.

FIGURE 11.12
18TH CENTURY HANDBILL

scientific research for sponsors, or in an assessment of damage for insurance adjustors or police after a fire or bad accident. Sometimes they shot photos of a company and its employees (Figure 11.10).

Photographers like Margaret Bourke-White and Ansel Adams took a number of photos for industrial clients both before and after they became famous.

Bourke-White saw an inherent beauty in industrial objects, according to her biographer, Jonathan Silverman. She liked machine forms. "It is only recently that artists have come to realize that a dynamo is as beautiful as a rose," she said. "It is beautiful because of the simplicity of its form."

ADVERTISING PHOTOGRAPHERS

Early advertising used symbols to represent products for sale. A Babylonian clay tablet from about 3,000 B.C. provides the earliest known example of advertising. The tablet contained inscriptions for a shoemaker, a scribe, and an ointment dealer. Later, signs found in the ruins of Pompeii held representations of what was for sale, for example, a boot for a shoemaker and a cow for a dairy. This early outdoor advertising survived into seventeenth century England as the signs above the doors of country inns.

Johann Gutenberg's invention of movable type in 1438 led advertisers to discover a new way to extol the virtues of their products: the printed handbill (Figures 11.11 and 11.12). The first ad to be printed in a newspaper appeared in England in 1695.

In 1704, *The Boston Newsletter* became the first newspaper to carry an ad in the American colonies. The first ads were more like today's classified ads. It took another 37 years before Benjamin Franklin used the first illustration in an ad for his famed store in 1741.

Advertising grew and prospered as the American colonies gained independence from England. In the young country, the machine age arrived by the early nineteenth century and with it, the ability to produce goods on a scale unknown before. Manufacturers needed to sell their products over as wide an area as possible, beyond the local region they had concentrated on before. They discovered that advertising was a great help in this effort.

For outdoor life and relaxation, Shur-on all-shell spectacles are comfortable and safe.

Shur-on eyeglasses, white gold mounted, lend poise and distinction to formal evening clothes.

Shur-on Shelltex rimmed eyeglasses supply the right note with business or professional attire.

Glasses reflect your judgment

DIFFERENT styles of glasses to suit different occasions—that's a matter of good taste and common sense.

Scientific precision, permanent fit— these call for keen discrimination in selecting glasses known for high quality.

Have yourself fitted with Shur-ons and you get not only the right styles for *you* and your activities, but superfine lenses, specially tempered metal that holds its shape, the work of the most expert craftsmen in the industry.

Shur-on Twintex spectacles have a patented double-strength joint that maintains the delicate original adjustment and thus saves the eyestrain resulting from poorly fitting glasses

Send for the authoritative booklet, "STYLE IN GLASSES"

All types of SPECTACLES *and* **Shur-on** EYEGLASSES

SHUR-ON STANDARD OPTICAL COMPANY, *Geneva, N. Y.*

The form of advertising changed as its importance rose. No longer were classified-type ads sufficient, or crude image representations little better than those from Pompeii. Advertisements needed larger type, easy-to-read copy, and illustrations of the products in order to succeed. This quickly led to what were (and still are) called display ads.

FIGURE 11.13
SHUR-ON EYEGLASS ADVERTISEMENT TAKEN FROM THE FEBRUARY 1927 ISSUE OF *THE GOLDEN BOOK* MAGAZINE

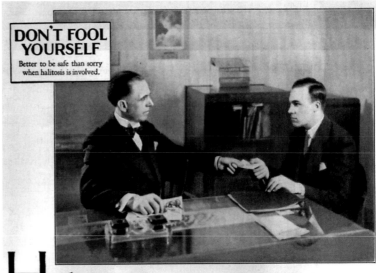

In 1844, the first magazine ad appeared in the *Southern Messenger*. Magazines were the first medium advertisers used to reach a new audience, probably because their higher-quality paper made ads look better than the poorer quality newspapers used.

In 1841, the first advertising agent opened his doors in Philadelphia. Volney B. Palmer contracted with newspapers

to get ad space, then resold it to advertisers. The first advertising agency, N.W. Ayer, went into business in 1890. Its rise—and that of others soon to follow—established the dominance of the agency in the advertising business, a situation that exists today. Clients can hire an agency to conduct research, write copy, design and execute and place ads to sell their products.

Photography was introduced into advertising as early as 1839, on a limited basis. It changed the advertising business forever. "Before photography, products could be depicted only by hand-crafted woodcuts on engraved metal drawings," write Courtland Bovee and William Arens in their book, *Advertising.* "Photography added credibility and a whole new world of creativity to advertising—it allowed products, people, and places to be shown as they really were, rather than as visualized by the artist."

Advertising did not really come of age until the early years of the twentieth century. At that time, it became legitimate to prepare ads about products and try to convince the public to buy them (Figures 11.13, 11.14, and 11.15). After challenges to advertising's credibility and two world wars slowed its growth, the industry achieved its place as a dominant medium of communication in 1950. That role is undiminished today, more than forty years later.

Photography has enhanced that domination, especially since World War II. First in black and white and later in color, photos have become the part of an ad that sells the product. And advertising photographers are among the most creative in the profession—and the best paid.

As with the other kinds of commercial photography detailed in this chapter, famous photographers have long done advertising work, both for the money and for the chance to explore yet another creative outlet.

Nature photographer Ansel Adams helped pay his bills with assignments from advertising clients. Adams wrote in his autobiography that clients rarely know what they wanted from a photographer. Although they don't want to look ridiculous or ignorant, clients will listen to photographers for advice.

FIGURE 11.15
WILLIAM'S SHAVING SOAP
ADVERTISEMENT FOR THE
MAY 6, 1905 ISSUE OF
THE SATURDAY EVENING POST

He explained one such instance:

A case in point was my assignment to photograph the Mark Hopkins Hotel. Before San Francisco was "Manhattanized," the Mark really dominated the skyline. The owner's instructions to me were to make the hotel tower rise high above everything and in the corner have a seagull as big as hell. I chose a telephoto lens and set my 8 x 10 view camera and tripod in the center of the lower California Street traffic. I lived through it without being run over, he liked the picture, and, happily, we both forgot about the seagull.

[From *Ansel Adams. An Autobiography*. Boston: Little, Brown & Company, 1985, page 105.]

One photographer who has gained his fame as much for his advertising photographs as for his creative images for museums and magazines is Richard Avedon.

Avedon began his career in the U.S. Merchant Marine during World War II taking thousands of I.D. photos. Here he discovered what he calls "the emotional geography of a face." He returned to New York and started taking fashion photographs for *Harper's Bazaar*. He has continued to mix fashion, advertising, journalism, and portraiture in the years since. In 1993, at 70, he still is working, "capturing his passions on film . . . locating himself at ground zero of American culture," wrote David Ansen in *Newsweek*. ". . . His very success as a commercial photographer has deemed him in the eyes of purists, for whom the terms 'fashion photographer' and 'artist' are mutually exclusive. But Avedon has triumphed by breaking the traditional rules of photography, embracing the contradictions of art and commerce."

Notes Avedon in his 1993 autobiography:

I've never been able to put all I know into a photograph. A photograph can be an adjective, a phrase. It can even be a sentence or a paragraph, but it can never be a chapter.

COLOR PHOTOGRAPHY: FROM HAND TINTING TO *NATIONAL GEOGRAPHIC* MAGAZINE

No publication has done more to advance color photography—for both professionals and amateurs—than National Geographic, *the monthly magazine of the National Geographic Society.*

COLOR PHOTOGRAPHY: FROM HAND TINTING TO *NATIONAL GEOGRAPHIC* MAGAZINE

Almost since there have been photographers, they have wanted their work to be seen in color. Their earliest efforts were primitive, but effective. They used dry pigments to tint daguerreotypes and watercolors to paint calotypes.

EARLY COLOR EXPERIMENTS

Richard Beard took out a patent for a coloring method in 1842 but it went nowhere. In experiments in Europe in this same period, scientists added chemicals to the silver compounds for black and white photos, but nothing worked out.

Scientists and inventors in both the United Sates and Europe continued to experiment. They based their work on the premise that all colors in nature result from the primary colors of red, blue, and green. They believed all other colors could be duplicated by adding or by subtracting portions of them by using filters of complementary colors.

This led gradually to the method of taking photos in color today, which consists of two major systems.

The additive system, used primarily in color television, is based on the principle that combining equal parts of red, green, and blue creates white light. Different combinations of the three additive primaries yield different colors. In general, all other visible colors in the spectrum can be created with various mixtures of the three additive primaries.

The subtractive system is the reverse of the additive in that it starts with white light and uses filters to subtract colors from it. In this system, white light passes through filters for the three subtractive primaries—yellow, magenta, cyan—to create other colors. The subtractive system has had wide use in color photography and in full-color printing.

ENTER KODACHROME

Kodachrome film was a major step in photographic history. Two technicians working at an Eastman Kodak laboratory perfected a film that incorporated three superimposed black and white emulsions. Each emulsion was sensitive to one color: blue, green, or red. They then used intricate processing to replace the black and white image in each layer with the corresponding dye image: yellow, magenta, or cyan. This process solved the problem of graininess and dot patterns that had plagued color photography, according to Jane Livingston, chief curator of The Corcoran Gallery of Art, writing in the centennial issue of *National Geographic*. Although a long time in coming, color film had a big impact when it became available commercially in 1935.

THE RISE OF *NATIONAL GEOGRAPHIC*

No publication has done more to advance color photography—for both professionals and amateurs—than *National Geographic*, the monthly magazine of the National Geographic Society. Although it did not publish a hand-tinted color photograph until 1910, the *National Geographic* was a showcase for photographers almost from the first issue of October 1888 (Figure 12.1).

The May 1902 eruption of the Pelee volcano on the island of Martinique in the Caribbean resulted in what became the magazine's guiding principal. Managing editor Gilbert H. Grosvenor sent a telegram to inventor Alexander

Graham Bell, president of the parent National Geographic Society, asking for approval to spend $1,000 to send a two-man scientific expedition to the scene.

Bell's reply has been called the magazine's first charter: "Go yourself to Martinique in interests of Magazine and I will pay your expenses . . . This is the opportunity of a lifetime—seize it. Start within 24 hours and let the world hear from you as our representative. Leave Science to . . . others and give us details of living interest beautifully illustrated by photographs."

From his first day as president in 1898, Bell felt the magazine was a means to build a great organization. It was his idea to allow anyone to join and thus participate in the explorations and discoveries of the society, which had started out as a small, rather elite organization of geographers and scientists and their wealthy patrons. Before Bell's decision, support for private expeditions came only from a few scientists and men of wealth.

The public had long been fascinated with reports of strange people living in remote places and the travails endured by explorers to get to them. By being admitted to membership in the society, anyone at any economic level could be a part of these adventures. Over objections from the board, Bell pushed the idea through and membership—at about 1,000 when he took over—had increased to 107,000 by 1912. Each member got a subscription to the magazine.

Grosvenor would be the daily manager and bring Bell's overall concept into reality. Although a writer and editor by training, Grosvenor constantly pushed for more and better photographs in the magazine.

"The features of most interest are the illustrations," he wrote to his wife in 1907. ". . . The most disappointing feature of the Magazine is that there is so little in the text about the pictures. . . . It seems to me that one notable line for improvement would be either to adapt the pictures to the text or the text to the pictures. Why not the latter?"

By 1908, half the pages of most issues were devoted to photographs. In the November 1910 issue, Grosvenor achieved another first: twenty-four pages of hand-tinted photographs of scenes in Korea and China. They were black and

Photos in this section were taken by Chris Johns,

a National Geographic *contract photographer.*

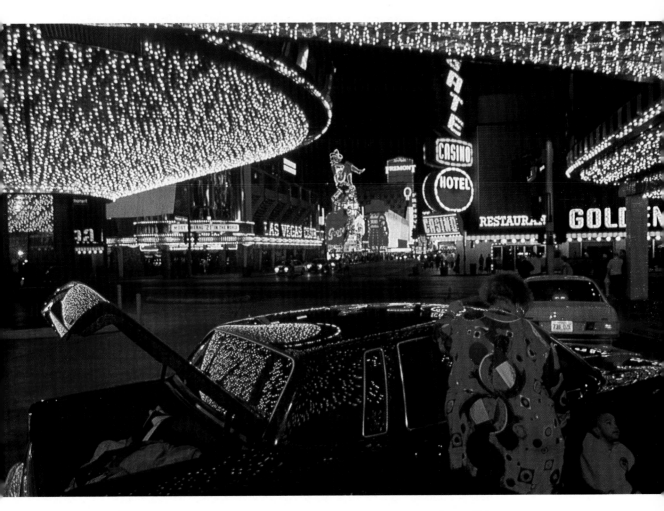

FIGURE 12.2
ALONG ROUTE 93, PHOENIX,
ARIZONA TO JASPER, ALBERTA
[Published with permission of Chris Johns]

FIGURE 12.3
ALONG ROUTE 93, PHOENIX,
ARIZONA TO JASPER, ALBERTA
[Published with permission of
Chris Johns]

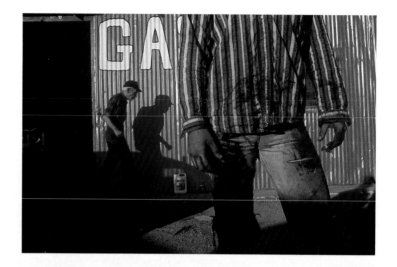

FIGURE 12.4
ALONG ROUTE 93, PHOENIX,
ARIZONA TO JASPER, ALBERTA
[Published with permission of
Chris Johns]

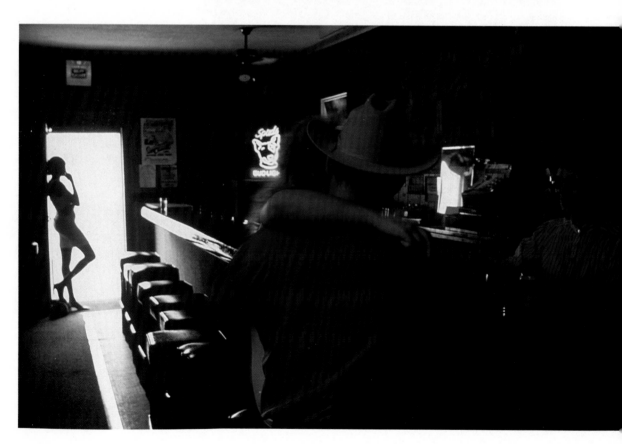

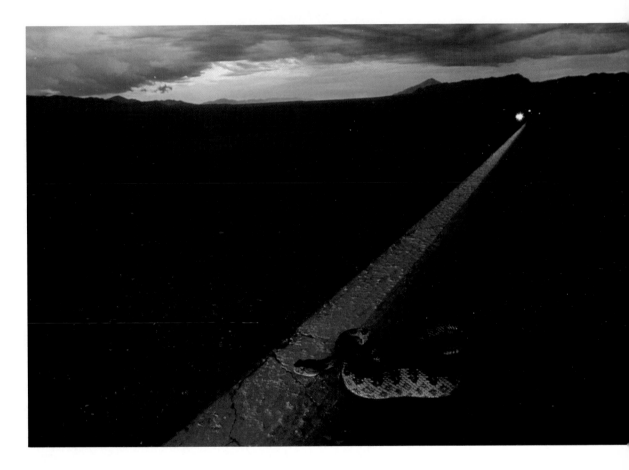

FIGURE 12.5
ALONG ROUTE 93, PHOENIX,
ARIZONA TO JASPER, ALBERTA
*[Published with permission of
Chris Johns]*

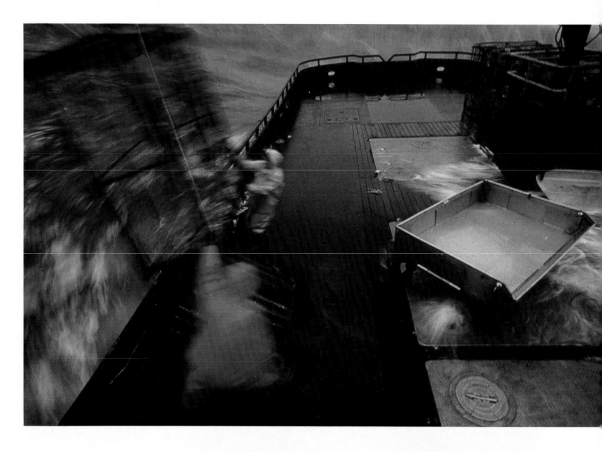

FIGURES 12.6 AND 12.7
CRAB FISHING IN ALASKA'S
BERING SEA *[Published with*
permission of Chris Johns]

FIGURE 12.8
LOGGING OLD GROWTH FORESTS
NEAR KETCHIKAN, ALASKA
*[Published with permission of
Chris Johns]*

FIGURE 12.9
LOGGING OLD GROWTH FORESTS
NEAR KETCHIKAN, ALASKA
*[Published with permission of
Chris Johns]*

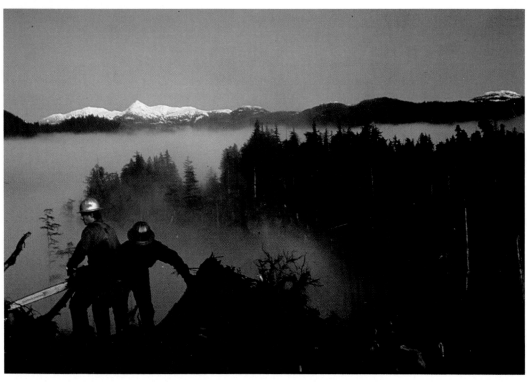

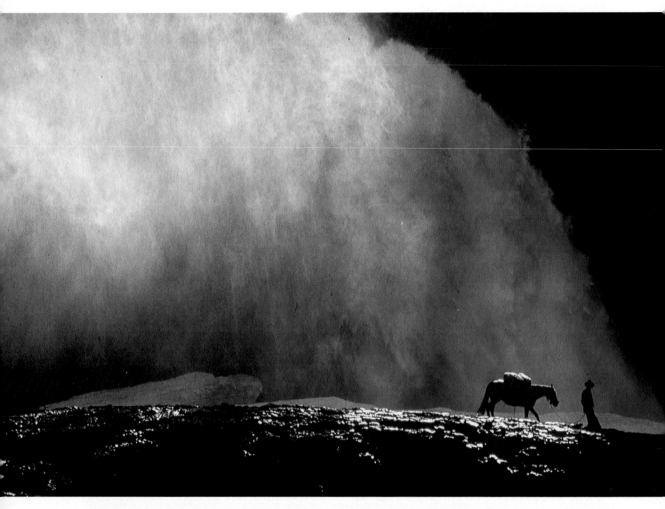

FIGURE 12.10
FISHING AND HORSE PACKING
IN MOUNT ROBSON PROVINCIAL
PARK, BRITISH COLUMBIA *[Published
with permission of Chris Johns]*

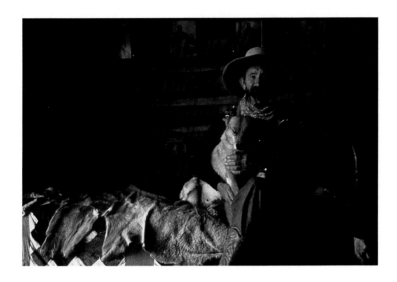

FIGURE 12.11
A WYOMING COWBOY AND HIS
DOG [Published with permission of
Chris Johns]

FIGURE 12.12
JOHN AND JOSEY ADAMS
WATCHING TV IN THEIR CAR NEAR
MCBRIDE, BRITISH COLUMBIA
[Published with permission of
Chris Johns]

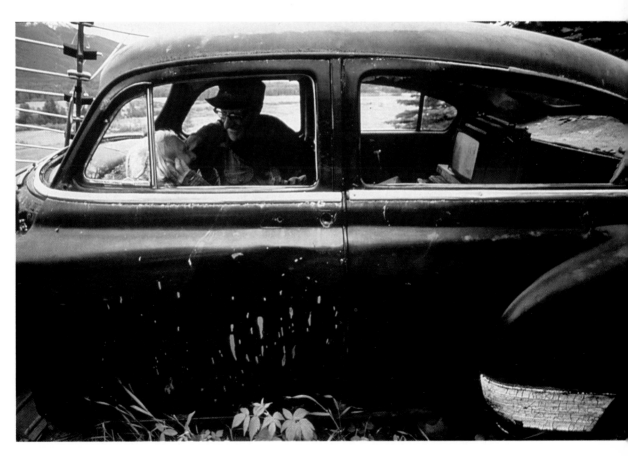

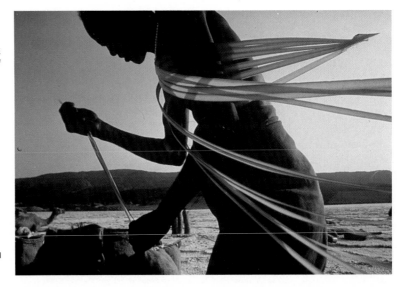

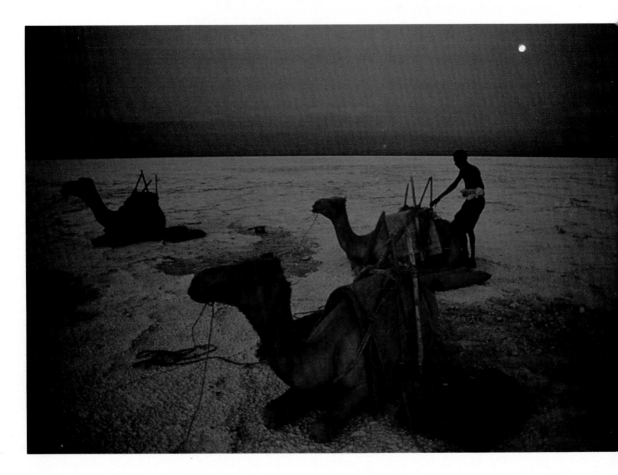

white photos that had been colored by a Japanese artist. Readers were so delighted that the editor included a color feature in every November issue after that.

In 1910, the Society established its own photo processing laboratory in its Washington headquarters. It hired a number of full-time photographers throughout the next decade.

The magazine first published a halftone of a color image in 1914. But regular use of color photos had to wait for technological improvements. The Autochrome process brought color photography into the mass market via the pages of *National Geographic*.

This process, invented by Augusto and Louis Lumiere in Lyon, France in the early 1900s, used a potato-starch filter deployed on a glass plate. It was demonstrated publicly for the first time in New York City in 1907. There the public saw the first Autochrome plates, one-eighth inch thick, taped at the edges.

COLOR AND THE *GEOGRAPHIC*

The Geographic published its first Autochrome plate in July 1914. It set up a color laboratory in 1920, the first by an American publisher. Ironically, the rather primitive starch-filter, glass-plate method remained the standard for a decade. Between 1920 and 1930, the magazine published 1,700 Autochromes.

The early decades of the twentieth century brought a number of possible replacements for the bulky, hard-to-handle Autochrome. None really caught on until the arrival of Kodachrome film. It had a number of advantages over Autochrome: it could be used in smaller cameras, it had faster exposure time, its chromatic appearance was more accurate, it could be enlarged without losing detail.

"By the 1940s, and 1950s, Kodachrome film and the lightweight Leica camera had brought new opportunities for nature photography," writes Jane Livingston in the centennial edition of the *Geographic* in 1988. "The ability to capture animals moving in their natural habitats, to say nothing of geologic or meteorologic cataclysms, has had momentous consequences for photography. *National Geographic* chose to use color, more color, and finally all color, at a time when

other publications shied away from it. This unswerving editorial commitment had profound aesthetic results."

By the early 1960s, the magazine was running all of its photos in color, except for an occasional historic black and white shot. With its 10.1 million members, the society has grown beyond what Grosvenor might have expected. It had more than 2 million members when he retired as editor in 1954 after fifty-five years in that job.

THE IMPACT OF THE *NATIONAL GEOGRAPHIC*

The *National Geographic* has had a big impact on everyone it touched—from readers who marveled at the beautiful photographs to scientists and explorers whose expeditions it funded. It has also influenced other magazines with its wide use of color. *Life, Fortune,* and *Look* all published color regularly beginning in the 1940s. *Life* had a special impact because of its large format and decision to allow photographs—and photographers—to drive the text.

Today, the majority of popular magazines in the United States publish most of their photos in color, unless they are striving for the more stark effect of black and white.

So much of what a reader sees today in magazines—and what photographers are hired to shoot—derives from *National Geographic* and another dictum from Alexander Graham Bell: the magazine would report on "the world and all that is in it," he said.

(The color section on pages 153 to 160 is representative of the fine photographs appearing every month in *National Geographic*—Figures 12.2 to 12.14.)

CAMERAS AND FILM REVISITED

CHAPTER 13

In 1900, Eastman Kodak had introduced

the Brownie. . . . Gradual refinements

in this simple design resulted in 1963's

Kodak Instamatic. . . .

CAMERAS AND FILM REVISITED

FIGURE 13.1
1961 MODEL OF THE SUPER
SPEED GRAPHIC CAMERA

The increasingly wide use of cameras in photojournalism, advertising, and documentation in the early twentieth century resulted in new cameras and slight modifications to existing ones.

In 1910, two flexible-plate cameras came on the market: the Linhof from Germany and the Speed Graphic from Eastman Kodak. The Speed Graphic (Figure 13.1) became popular with newspaper photographers, in part because it contained its own flash gun.

REFLEX CAMERAS

Although first invented in the 1890s, the single-lens reflex camera evolved into smaller and lighter models early in the twentieth century, as noted in Chapter 3. The first models had to be held at waist level so the image being photographed could be reflected on an internal mirror. The greatest improvement came with the addition of a pentaprism, which made eye-level viewing possible.

The introduction of the twin-lens reflex camera came next. Although invented in 1889, it did not reach wide use until 1928. Twin-lens reflex cameras (Figure 13.2), as their name suggests, have two lenses: one for viewing and focusing, the other for taking the picture. The two matched lenses are located one above the other, on the front of the camera. The picture is composed and focused on a ground-glass viewing screen on the top of the camera. The camera is called a reflex because the light that forms the image on the ground glass is reflected off a mirror that turns the image right-side up. The chief advantages of twin-lens reflex cameras are their simplicity, durability, and quietness.

FIGURE 13.2
THE ROLLEIFLEX AUTOMATIC 3.5 E
TWIN-LENS REFLEX CAMERA

Just before World War I, the Leitz Company in Germany—until then manufacturers of motion picture cameras—designed a small camera for testing motion picture film. The camera was intended as an exposure meter of sorts; it made trial exposures on a strip of film, which then was developed to determine development compensations for film shot in the cinema camera. The images on the test film were so clear, however, that they could be enlarged to make very good prints.

THE 35MM LEICA

World War I interrupted refinements on this camera, but the company had it ready for introduction by 1924. Called the Leica (Figure 13.3), the single-lens reflex camera used 35mm film of the same size used in motion picture cameras. By the 1940s, refinements in

FIGURE 13.3
THE LEICA I MODEL A 35 MM
CAMERA OF 1925

size made this camera the choice of many professional photographers because of its quietness and ability to use fast film even in low light situations (Figure 13.4).

Cameras for amateurs were changing too. In 1900, Eastman Kodak had introduced the Brownie, a fixed focus camera that was cheap to buy and simple to operate at waist level (see Chapter 3). It consisted of a shutter reflex to snap the picture, a film-winding key to advance the film roll after each exposure, and v-lines marked on top to help in aiming. Gradual refinements in this simple design resulted in 1963's Kodak Instamatic (Figure 13.5), a lightweight camera that used film cassettes and could be held at eye level.

FIGURE 13.4
ASAHI PENTAX ELECTRO
SPOTMATIC ES II 35 MM
SINGLE LENS REFLEX CAMERA

POLAROID

In 1947, Edwin H. Land's invention of the Polaroid camera (Figure 13.6) added another dimension to photography: a positive proof produced instantly. The process involves chemical transfer of exposed silver halide crystals from a negative to a second sheet of paper on which the crystals are reduced to metallic silver to form a positive image.

Color Polaroid film became available in 1963. This camera revolutionized the amateur market because people could

CHAPTER 13

now know right away if their pictures would be successful. If not, they could take more. Professionals started using Polaroids to take test shots to check studio lighting arrangements.

By the 1970s, use of 35mm cameras such as Leicas and Nikons had extended beyond professionals to the amateur market.

FIGURE 13.5
THE KODAK INSTAMATIC 100
OF 1963

Changes in flash illumination were keeping pace with the cameras they were connected to. In the 1860s, photographers needed to ignite magnesium to put light on their subjects. The invention of the flashbulb in 1925 made the old method obsolete. The bulb encased the magnesium wire in glass, safely and without smoke. In 1938, Harold Edgerton of the Massachusetts Institute of Technology perfected the electronic flash tube. This tube, with its brief and bright light, made possible photography of high-speed events in science and industry. Later refinements in flash techniques included flash synchronization built into cameras and high-speed electric flash units.

FILM

Film was changing too. The biggest example of this change was in the increased film speed, that is, in film's sensitivity to light; the faster a film is the more adaptable it is to all shooting conditions.

In 1935, color film for making positive transparencies appeared. Color negative film became available in 1942. Amateurs and professionals eagerly embraced it.

By the late 1970s, photographers were facing the same fact many other consumers were discovering: the earth has limited resources. For the photographer in particular, there is only so much silver economically available. The world economy had driven up the price of gold, and the price of silver rose soon after. The price of silver-based photographic materials doubled over a period of a few weeks. Photographers began diligently to reclaim silver from used fixer, the chemical that renders a photographic image stable on film or print. Indeed, nearly half the silver Kodak uses is reclaimed from fixing baths at its processing labs.

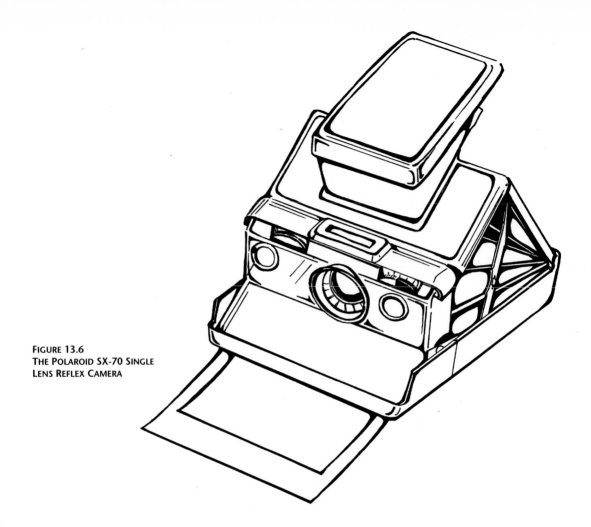

FIGURE 13.6
THE POLAROID SX-70 SINGLE
LENS REFLEX CAMERA

The introduction of chromogenic black and white film was an attempt to solve this problem. This film allows all its silver to be removed and reused after development, with black dye remaining to record the photographic image. But the cost of silver added pressure to efforts already underway to find an alternative to photographic methods based on silver's light-sensitive properties.

That search occurred in the midst of a new photographic revolution—an electronic one. It will be described in Chapter 15.

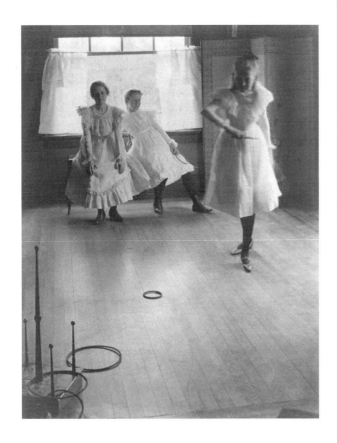

PHOTOGRAPHY
AS ART REVISITED

". . . To take photographs means to recognize—simultaneously and within a fraction of a second—both the fact itself and the rigorous organization of visually perceived form that give it meaning. . . ."

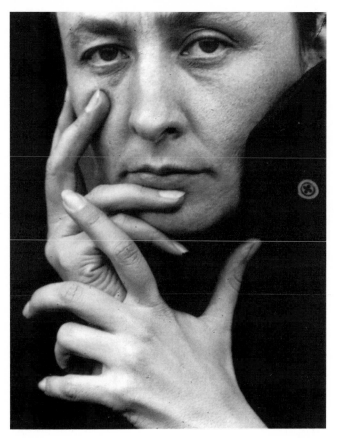

FIGURE 14.1
GEORGIA O'KEEFFE BY ALFRED
STIEGLITZ, 1918 [SILVER CHLORIDE
PRINT, 11.5 X 9.1 CM, ALFRED
STIEGLITZ COLLECTION, 1949.742]
*[Photograph courtesy of The Art Institute
of Chicago.]*

PHOTOGRAPHY AS ART REVISITED

As the twentieth century began, the evolution of photography as an art form accelerated. It even had a name: pictorialism. According to photo historian Naomi Rosenblum, this movement flourished between 1899 and World War II. Several factors caused its growth, Rosenblum states: simplified processes and procedures, the widely varied uses of photography, and an increased public appreciation of all things visual.

ALFRED STIEGLITZ

As noted in Chapter 2, Alfred Stieglitz brought the photographic medium into the modern era. He was a pictorialist, but he had started working in the vastly different Victorian era. As a result, he served as a link between both. Some of his most memorable art photographs were taken of his wife, the artist Georgia O'Keeffe (Figure 14.1).

Pictorialists chose natural landscapes and the nude female figure as their subjects. The former looked like paintings, the latter produced a great deal of controversy. As a way to lessen the public shock at seeing photos of naked women, photographers depicted the women in classical settings, as nymphs. Gradually, they began to shoot their subjects in more realistic settings and poses, arguing that the nude could be graceful on its own.

In the early 1900s, devotees of artistic photography were setting up their own photographic societies, similar to groups that had flourished for years to encourage the growth of the medium in general. These new specialized societies encouraged photographers to follow their artistic leanings, organized exhibitions, and encouraged museums and galleries to display artistic photographs. The Photo-Secession in New York was an important organization in the United States, as was the Linked Ring, its London counterpart.

Stieglitz organized the Photo-Secession in 1902 to promote what he called "the serious recognition of photography as an additional medium of pictorial expression." Eventually, the group had one hundred members, including Edward Steichen and Clarence H. White. A number of women played prominent roles as well, as noted in Chapter 10.

EDWARD STEICHEN

Steichen began his long career as a painter. When he switched to photography he manipulated techniques in new ways. For example, he used gum and pigment processes along with conventional platinum to create haunting and subtle images. Throughout his career he took a number of memorable portraits (Figure 14.2). He had later success as an advertising and fashion photographer and served as director of the Department of Photography of the Museum of Modern Art.

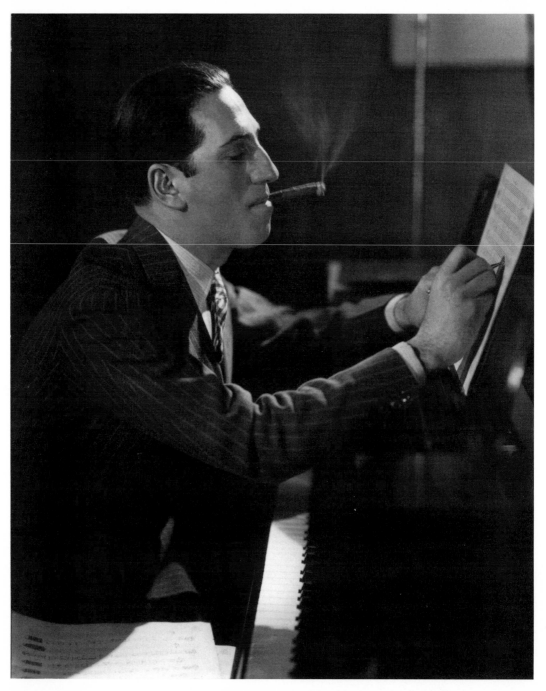

FIGURE 14.2
GEORGE GERSHWIN BY EDWARD
STEICHEN *[Reprinted with permission of Joanna T. Steichen]*

During World War II, he directed part of the official documentary effort of the U.S. government. He died in 1973 at age 94.

CLARENCE WHITE

Clarence White was the antithesis of Stieglitz and Steichen. His Midwestern background made him less flamboyant and bohemian than his two contemporaries. He usually chose gentle subjects for his photos, many revolving around family life, often featuring women (Figure 14.3). He started his working life as an accountant in a grocery company and ended it as an important photographer and teacher. After teaching at Columbia University and the Brooklyn Institute of Arts and Sciences, he established the Clarence White School of Photography in 1914.

He and Stieglitz worked closely at first, even collaborating on a series of nude studies. They later fell out over White's adherence to pictorialism because Stieglitz felt that style had become passé.

Between World War I and World War II, photography of all kinds flourished as never before, in journalism, advertising, and art. Some photography became as wild and experimental as paintings done in the same time period.

With its roots in Europe, this so-called "New Vision" photography became firmly established in the United States in the 1920s. It was called precisionism.

MAN RAY

An early proponent of this new approach was Man Ray. Although he was an American, Ray did most of his most noted photos in Paris. In his works, which he called "Rayographs," he arranged translucent and opaque materials on photographic paper and exposed them to stationary or moving light sources. The results were unusual and attracted a lot of public attention. In effect, they were "camera-less" images.

A Hungarian photographer, Laszlo Moholy-Nagy, became equally famous with his "photograms" (Figure 14.4). He believed that photographs should be concerned more with light and form than personal feelings. The resulting images were very abstract and resembled Ray's work in their depiction of objects.

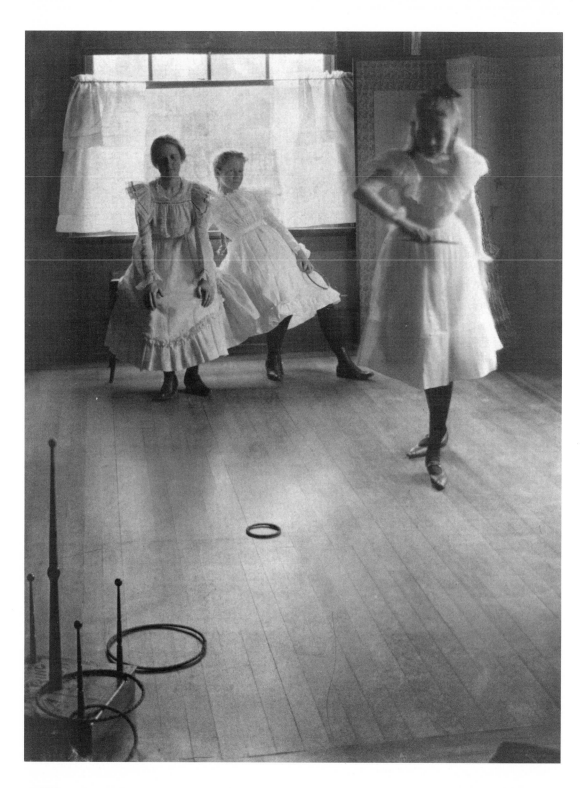

(Opposite)
FIGURE 14.3
RING TOSS BY CLARENCE WHITE,
1899 [PLATINUM PRINT] *[Courtesy
of the Library of Congress]*

FIGURE 14.4
UNTITLED [ABSTRACTION] BY
LASZLÓ MOHOLY-NAGY
[GELATIN SILVER PRINT, N.D.
50 X 40 CM, GIFT OF GEORGE
AND RITA BARFORD, 1968.264]
*[Photograph courtesy of The Art Institute
of Chicago. Published with permission of
Hattula Moholy-Nagy]*

PAUL STRAND

Paul Strand was a follower of Stieglitz who embraced precisionism wholeheartedly. He thought that photographers should combine the objective nature of reality with the sharp lens of the large-format camera, according to Rosenblum. His subjects ranged from urban scenes to machine forms to unusual buildings (Figure 14.5) to nature. He later worked as a film-maker in California and Mexico before returning to photography full-time.

Women were prominent in precisionism, as noted in Chapter 10. So were Western photographers such as Ansel Adams and Edward Weston (see Chapter 6) and documentary photographers such as Walker Evans (Figure 14.6).

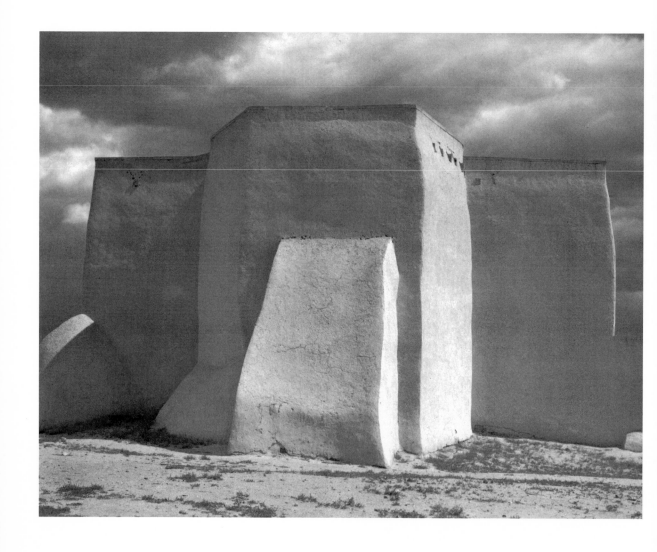

FIGURE 14.5
CHURCH, RANCHOS DE TAOS,
NEW MEXICO BY PAUL STRAND,
1931 [©1971, Aperture Foundation,
Inc., Paul Strand Archive]

The increased industrialization of the 1920s and 1930s made machines a popular subject for precisionist photographers. Weston, Strand, Steichen, Margaret Bourke-White, and Imogen Cunningham all took photos of machines such as lathes and processes such as steel making for both industrial clients and their own portfolios.

MAKING THE CONVENTIONAL, UNCONVENTIONAL

Beginning in the 1930s and continuing to the present, a new kind of art photograph has emerged. It depicts everyday scenes as subjects but captures them in startling and evocative ways.

An early proponent of this style was Weegee, whose real name was Arthur Fellig. A free-lance newspaper photographer working much of his time in New York, Weegee gained fame because viewers could immediately tell what his photos were about without even looking at the caption.

In more recent years, a number of photographers have gained fame with a variety of styles.

There are documentary photographers such as Roman Vichniac, Sebastiao Salgado, and others. Vichniac photographed Eastern European Jews in Poland just before World War II. The photos seem more haunting today because so many of those people were killed in the Holocaust. After the war, Vichniac gained fame for his microphotographs of scientific subjects published in *Life*.

Salgado, a Brazilian economist by training, captures the lives of workers around the world on film. His 1993 show, "Workers: An Archaeology of the Industrial Age," was well-received. He feels close to his downtrodden subjects and critics think that empathy comes across in his work. ". . .(I)n the end," he told *Rolling Stone* in 1991, "it's not really the photographers who take the pictures, it's the persons in front of the camera who give the photos to you."

Eugene Richards, Bruce Davidson, and Mary Ellen Mark are other noted documentary photographers. Whether photographing the Civil Rights movement or big city poverty or a hundred other compelling subjects, these three and many others captured the reader's attention.

Manipulative photographers have gained fame as well. Jerry Uelsmann uses montage to create unusual photos. He pieces together various negatives to form an image that could never exist on its own, for example, a room with clouds on the ceiling or a garden in daylight with a large moon in the sky.

Duane Michaels stages events using himself and other as models. In one, "Chance Meeting," two men pass

each other in an alley over a series of six frames, displaying different reactions.

Modern artists are another category. This group includes Minor White and Eliot Porter. White is considered by some critics as the photographer who linked Alfred Stieglitz, Edward Weston, Ansel Adams, and Paul Strand with modern photographers. In the 1950s, White developed a new photographic approach that, in the words of one critic, "blended the hard formalism of Western taste (Adams and Weston) with the more subtle and intellectual stance of the East Coast masters, Stieglitz and Strand," White lived his life through his photos, often including in them moments of intense emotion. He constantly urged that photos convey a mystic sense, this feeling no doubt influenced by his study of Christian mysticism.

The artistry present in natural landscapes was Eliot Porter's subject. His distinguished career in photography did not begin until he was 37. Before then, he taught bacteriology and biological chemistry. He took photos as a hobby and showed a few to Alfred Stieglitz, who offered to stage a show in his gallery, An American Place, in 1938. Overwhelmed by the honor, Porter decided to give up research and become a professional photographer. Beginning with photos of birds and later expanding his subject matter to nature as a whole, Porter was influential through a series of books beginning with *In Wildness is Preservation of the World,* published in 1962 by the Sierra Club. His involvement with the organization gave him a whole new reason to be a photographer. "The reason for photographing was not just to satisfy myself, or to produce attractive photographs for exhibition or publication, but to show people who have not seen these places what the world contains in the way of natural beauties and wonders," explained Porter.

Last in this description of recent art photographers are David Hockney and Cindy Sherman. Hockney's color photographs are often like paintings in their composition and unusual views. His basic premise, in one critic's opinion, is to communicate directly with the viewer. "Hockney is not at all involved in the creation of beauty as an end in itself," wrote the critic. "It is exactly this didactic urgency, this need to be heard plainly and to be understood clearly, which is the basis of his phenomenal popularity."

Cindy Sherman takes photographs of women, often herself. In her early work in the 1970s, she transformed herself into different characters and photographed the process and results. Having exhausted all stereotypes she could imagine, Sherman began a series of photographs using rear screen projections. Standing in front of a screen with an outdoor image, she could create the illusion of being elsewhere, even though she was working in her studio. She has continued to experiment in the years since and is considered by critics to be among the most inventive of modern photographers.

THE LEGACY OF CARTIER-BRESSON

Styles in photography may come and go, but the legacy of one man has been among the most durable of all photographers in the twentieth century.

The Frenchman Henri Cartier-Bresson was more influential as an artistic photographer, but his subjects were often commonplace.

He began his career as a painter but switched to photography in 1930. He is seen as a photojournalist, but one whose work captures precise moments in life in an artful way. His phrase "the decisive moment"—the single instant when objects within the camera viewfinder organize themselves into the right combination—defines what all photographers are seeking.

His long career took him to Mexico, the Spanish Civil War, and to Europe in World War II, during which he was captured by the Germans. After the war he co-founded the Magnum photo agency, traveled all over the world, and even made films. In 1993, he celebrated his eighty-fifth birthday.

His words in a 1976 collection of his photos could serve as a credo for all photographers:

> To take photographs is to hold one's breath when all faculties converge in the face of fleeing reality. It is at that moment that mastering an image becomes a great physical and intellectual joy. To take photographs means to recognize—simultaneously and within a fraction of a second—both the fact itself and the rigorous organization of visually perceived form that give it meaning. . . .

THE FUTURE OF PHOTOGRAPHY

The computer can combine images with ease and flexibility. That facility opens new doors for the artist, but creates credibility problems for the documentary photographer and the photojournalist. . . .

THE FUTURE OF PHOTOGRAPHY

Books written about the history of photography some 50 or 100 years from now will hail the era around the year 2000 as a time of revolution for photography—the era of transition from photography as a chemically based medium to an electronically based medium. The transition will have produced profound effects in the methods and applications of photography. It is impossible to predict with precision what all of those effects will be, but some educated guesses about general impacts and possible developments can be made.

CHEMICAL AND ELECTRONIC PHOTOGRAPHY

In the chemical approach to photography, images are captured on film in a camera, stored on processed film, manipulated in the darkroom (perhaps by burning and dodging or by adjusting contrast), and printed on photosensitive paper. Transmitting the image to someone else usually involves dropping it in the mail or handing it to a delivery service. Images also can be shown in a slide show, allowing others to view the image even though it is not in hard copy form like a print.

The electronic approach to photography also involves these functions, even though they are performed differently. The image is captured by a photosensitive electronic chip and stored as an electronic file on a disk like those used in a computer. The image can be manipulated extensively on a

FIGURE 15.1 THE MAVICA
ALL-ELECTRONIC CAMERA
[Courtesy of Sony Electronics Inc.]

computer using image processing software. Prints can be produced by various kinds of printers, yielding varying degrees of quality, some very crude and others approaching the quality of a well-made photographic print. Images can be transmitted by fax, by computer network, or by telephone via modem. And, of course, the image can be viewed on a computer screen or a television set without making a hard copy.

DEVELOPMENT OF ELECTRONIC PHOTOGRAPHY

Many people place the beginning of electronic photography at August 24, 1981, the date that Sony introduced the Mavica, the first commercially available electronic still video camera (Figure 15.1). The Mavica's historic significance was not lost on Sony, which said in its press release

The conventional camera has seen some improvements over the years, such as the change from dry plate to film, the use of electronics in certain parts, and the reduction of size and weight. However, for more than 140 years since the invention by Daguerre of France, there has been no fundamental change in the concept and technology of photography, in which images are recorded on film through chemical reactions of photo-sensitive materials.

While the introduction of the Mavica was indeed historically significant, it was not the only landmark event in the development of electronic photography. Electronic photography involves much more than new camera technology. It also entails computer manipulation of images—the so-called digital darkroom—as well as new methods of storing and viewing photographs, electronic transmission of photographic images from point to point, new methods of producing color prints, even new ways to publish photographs electronically.

Electronic photography encompasses a wide range of technologies. Three of the most significant are the development of the personal computer, the development of image processing software, and the development of the charge-coupled device (CCD).

The personal computer. The first general purpose electronic computer, the ENIAC, was designed in 1945. It was two stories high and weighed thirty tons. In 1974, about thirty years later, the first microcomputer, the Altair, was introduced on the cover of *Popular Electronics*. It was as powerful as the ENIAC, but could fit in a suitcase. The Altair took advantage of new microcomputer chips developed by Intel in 1973. The machine lacked the basic software needed to use it, so two young men in their late teens created an operating system. In order to market the software, the two, William Gates and Paul Allen, established a company the following year called Microsoft. However, even with an operating system, the Altair was more of a hobbyist's curiosity than a serious tool. It was not commercially successful.

Commercial success came with the introduction of the Apple II computer in 1977. Designed and built by Steven Jobs and Steve Wozniak in a garage, the machine's capability was limited, but it started the personal computer revolution. Apple Computer continued to work on making

microcomputers that were more sophisticated and easier to use, and in 1985 introduced the Macintosh. The Macintosh was designed with a graphical user interface, making interaction with the computer more visual and less dependent on remembering arcane keyboard commands. At the same time, its facility with graphics made it an ideal machine for software that dealt with images—drawing programs, paint programs, and eventually image processors.

In the meantime, International Business Machines, the giant of the computer industry, entered the personal computer market in 1981. IBM contracted with Microsoft to write the operating system for the new IBM PC, and MS-DOS (Microsoft Disk Operating System) eventually became the standard for some 90 percent of the world's microcomputers. Unlike the Macintosh system, however, MS-DOS was not graphical, was more difficult to learn to use, and did not lend itself to graphic applications. Microsoft addressed that shortcoming by starting development of Windows in 1985. Windows gave MS-DOS computers much the same visual personality of the Macintosh. Within a few years, most widely used imaging software was available for the Macintosh and Windows.

Widespread access to personal computers fueled the development of equipment and computer programs needed for electronic photography: large storage devices, sophisticated

FIGURE 15.2
THE PRISMAX II, AN IMAGE MANIPULATION WORKSTATION
[Courtesy of Scitex America Corporation]

image processing programs, faster computers capable of the intense computation required to process images. Developments in xerography and lasers led to the design of many of the printers used to make prints in the new digital darkroom. Developments in the publishing industry led to electronic methods of storing images and transmitting them from one location to another.

Image processing software. Image processing, the manipulation and enhancement of images stored in a computer, first was developed by the National Aeronautics and Space Administration (NASA) in the mid-1960s. Unmanned flights to map the moon's surface returned thousands of television images that were digitized and then computer processed to improve sharpness and filter out static.

One of the people who worked with NASA on digital image processing was Efi Arazi, an Israeli high school dropout who had talked his way into MIT. He returned to Israel, founded Scitex in 1968, and went to work to apply digital processing techniques to the automation of the textile printing industry. Within a few years it became clear that the same technology could be used in the printing industry, where highly paid craftsmen spent hours preparing color photographs for publication. By 1979 Scitex had introduced the Response 300, a system that allowed computerized retouching, adjustment, and placement of color images and text on a display screen (Figure 15.2). The systems cost about $1.5 million, but saved much more in time and labor for the publications that could afford them. It was the beginning of image processing in the printing industry.

FIGURE 15.3
KODAK KAF-6300 FULL-FRAME IMAGE SENSOR (CCD) WITH 6.3 MILLION PIXELS
[Courtesy: Eastman Kodak Company. Kodak is a trademark of the Eastman Kodak Company]

By the mid-1980s similar programs were running on microcomputers. Computer programs such as Digital Darkroom, ImageStudio, and PhotoShop allowed photographers, designers, and printers to scan in photographs, retouch and alter them, and print them using equipment that cost less than $10,000.

The charge-coupled device. The development of the electronic camera dates back to 1970 and the charge-coupled device (CCD). The CCD was invented by W.S. Boyle and G.E. Smith at Bell Labs and is an outgrowth of the transistor, an earlier Bell Labs product that revolutionized electronics.

A CCD is the electronic equivalent of a piece of photosensitive film or paper. It is an electronic chip (Figure 15.3) containing microscopic light receptors that can sense light and convert it into an electronic signal. The electronic signal can be stored, transmitted, modified, and eventually converted back into an visible image on a monitor or paper copy. Cameras based on the CCD were developed by the mid-1970s for military and scientific applications. Imaging devices using CCDs since have been used to produce pictures of distant planets from NASA satellites and of the sunken luxury liner the *Titanic* via remote controlled submersible cameras. CCDs are the basis today, not only for still video cameras, but also for video camcorders and scanners.

ADVANTAGES, DISADVANTAGES, AND IMPLICATIONS OF ELECTRONIC PHOTOGRAPHY

Speed. Electronic cameras make images instantly available. These images can be transmitted rapidly from point to point via satellite, telephone, or computer network. They can be cropped or manipulated using a computer and then integrated into the layout of a publication. It is possible for the image to go from electronic camera to printing plate in minutes without ever existing as a hard copy print.

This kind of speed is most valuable in photojournalism, especially for wire services and newspapers. Most newspapers are involved in electronic photography to a certain extent. Some newspapers use electronic cameras where assignments warrant or deadlines are tight. Many newspapers continue to use conventional cameras, but utilize film scanners to move the images into a computer for editing and placement with text on the printed page. All Associated Press newspapers now use a computer to receive and edit wire photographs.

Editing and image processing. Photographers have been able to manipulate photographs for decades. They could adjust exposure by burning and dodging, adjust contrast by development or filtration, combine images by double exposing, as well as a host of other camera and darkroom procedures. The digital darkroom doesn't add much that is fundamentally new, but it does make this manipulative technology much more accessible, much easier, and much faster.

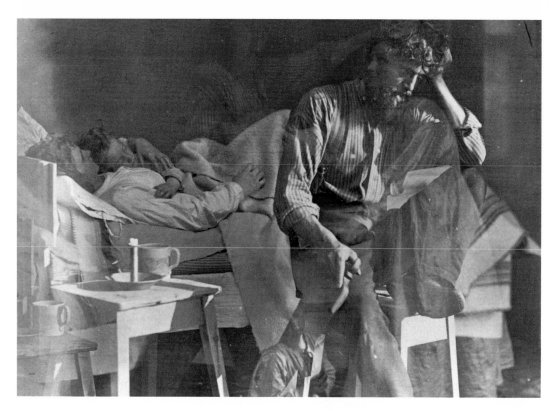

From Otto Rejlander's *Hard Times* (Figure 15.4) to the contemporary work of Jerry Uelsmann, photographers have created images that are photographic fictions. While they appeared to be authentic portrayals of reality, they were not. But convincing manipulated photographic images have been relatively rare in the past. It took a great deal of skill and care for the photographer to create them using purely photographic means. The electronic darkroom now makes it possible for anyone with some patience and a few hours training to accomplish the same thing on their desktop computer. Many, probably most, of the photographs appearing in advertisements today have been manipulated, often cosmetically, sometimes drastically.

Image processing has given art photographers a flexibility that in the past belonged only to painters or sculptors. Photographers largely were constrained to produce faithful reproductions of the reality that lay in front of their cameras. That, of course, was part of the fascination of photography. But it also limited the ability of the artist to interact with the

medium. A painter could return to the canvas and revise, remove, restore. The photographer generally was limited to slight modification in the darkroom.

Today's image processors have made the photographic image as malleable as the painter's canvas. Computer operations can darken, lighten, sharpen or blur the image, or completely transform it, creating what seems to be an entirely new image. In Figures 15.5A, 15.5B, and 15.5C, Oregon photographer and designer Don Poole makes a car seem to be flying.

The computer can combine images, much as Rejlander did (as explained in Chapter 2), but with far greater ease and flexibility. That facility opens new doors for the artist, but creates credibility problems for the documentary photographer and the photojournalist. Magazines, which have used image processing technology for more than a decade, occasionally have manipulated images to improve their composition. In one well-known case, the *National Geographic* electronically picked up one of the five million-ton Egyptian pyramids and moved it to one side to improve a cover photograph. The adjustment was slight, one the photographer could have achieved by moving about twenty yards to one side, but it clearly raises the issue: how much manipulation can be tolerated without damaging the credibility of the documentary photograph?

The National Press Photographers Association, which represents most of the newspaper photographers in the United States, has tackled the issue head-on. Its basic position is that any manipulation beyond what could be achieved easily in a conventional darkroom should not be tolerated. Burning, dodging, adjustments in contrast and exposure, or repair of dust marks and scratches are all acceptable. But anything that changes the content of the photograph—removing or relocating objects within the image, for instance—steps beyond acceptable bounds and damages the credibility of the newspaper photograph. It seems clear, however, that the future believability of the news photograph will be based, not on the nature of the technology, but on the credibility and honesty of those taking and editing the images.

Transmission, storage and distribution. The electronic nature of a digitized image makes it possible to transmit it by radio, satellite, or telephone almost instantaneously. That's essential in remote sensing applications, such as

satellite imagery, and it's a tremendous advantage for the photojournalist, who frequently has to move images from one part of the world to another for publication.

The digital image, in fact, may alter the nature of publication for many photographs. Kodak introduced the Photo CD in 1992. It made it possible for photographers to drop off a roll of color film at the local photo finisher and pick up a compact disk a few days later that contained all their images in digital form. The images stored on the CD could be

displayed on a television set or read into a computer for image processing. A single CD holds about one hundred images.

FIGURE 15.5C
"WINGED MERCURY" AN
ELECTRONIC IMAGE CREATED BY
DON POOLE [Courtesy of Don Poole. Printed with permission]

Interactive books now are being published in Photo CD format. The CD combines text, digitized sound, and photographs, and allows the reader/listener/viewer to interact with the book in a nonlinear way. The first such book was Rick Smolan's *From Alice to Ocean,* a video journal of a trip across Australia. Photo CD's also allow photographers a new way to distribute their portfolios or stock images for publication.

Sharpness and detail. The electronic still video camera has definite sharpness limitations in comparison with a conventional camera and film. Even the most advanced (and most expensive) still video cameras have only about twenty percent of the resolution of a 35mm negative. For some

applications, such as newspaper photography (where newsprint reproduction cannot resolve fine detail anyway), this limitation is outweighed by advantages in speed. For other applications, such as color magazine or book reproduction, a compromise in image quality is unacceptable.

Magazine and book publishers are nonetheless heavily involved in electronic imaging, although in a hybrid form. In this hybrid technology, photographic images first are taken on conventional film. The images then are scanned, either directly from film or from a photographic print, and converted into an electronic image file that can be stored in a computer. Film and print scanners often use the same type of CCD technology that still video cameras use, but can make slower or multiple passes over the image to improve sharpness and image quality. Once it is stored electronically in the computer, the image can be cropped, sized, color corrected, or manipulated using image processing software, then integrated with text, captions, or artwork in a desktop publishing program. This approach allows publishers to combine the high quality of conventional photographic processes with the speed and flexibility of electronic approaches.

It seems likely that, in time, electronic methods of image capture will improve so that they rival chemical methods, and electronic cameras eventually may replace conventional ones for most photographic applications. It also seems probable that people will continue to value the representative documentary image—photographs of things as they really appear. People probably will continue to enjoy what happens when realistic images are transformed within image processors to create new realities that challenge our imagination and perception.

Many people are predicting that electronic processes will result in a renaissance of photography, an explosion of new interest and exploration. If so, the basis of our fascination with photography probably will still remain what it was when Niepce and Daguerre were experimenting—the unvarnished reality of things recording themselves by light and shadow.

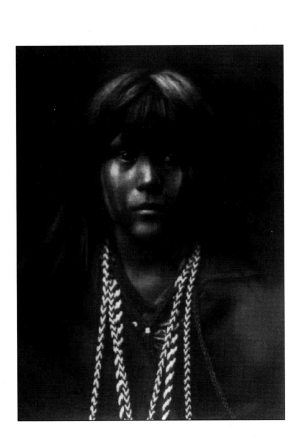

APPENDICES

APPENDIX A:
GLOSSARY

art photography	taking photos of people and objects that, when complete, look like paintings
autochrome	an early means to produce color photos
bellows camera	a camera in which a bellows-like mechanism serves to focus the lens
box camera	a camera of simple design containing a lens and a plate holder
calotype	the first successful negative/positive process to produce photos
camera lucida	an early way to copy drawings through use of a prism and lens
camera obscura	an early camera that was a room with a hole at one end that projected an outside image on an inside wall
commercial photography	taking photos of people, industrial objects, and advertising
daguerreotype	developing a latent image on a metal plate; the first practical way to produce a photo
electronic photography	using electronics on cameras and computers instead of darkrooms
folding bed view camera	a variation on a bellows camera in which screwed rods move the lens for focusing
genre photographs	photos of everyday life or humorous dramatic scenes created for the camera
glass plate	a plate covered with a light-sensitive material that receives the image through the camera lens
heliography	creating a three-dimensional image on film

Kodachrome	a later color film that superimposed three black and white emulsions, each sensitive to blue, green, or red; yellow, magenta or cyan were added later
magic lantern	an early camera containing a mirror for reflecting light
mousetrap cameras	early cameras containing removable paper holders
paper roll film	film that could be rolled through a camera to expose onto multiple images
photograms	a photographic image created without a camera
photojournalism	using photographs instead of words to tell a news story
pictorialism	an early twentieth century movement that considered the photograph an art form
pixel	picture element; a small cell, a component of a larger image, that may vary in tone from black through various shades of gray to white
precisionism	experimental art photography that flourished between the two world wars
reflex cameras	camera design, in both single lens and twin lens models, which uses a mirror to allow the photographer to see through the lens
wet collodion	making a photo negative by coating a sheet of glass with light-sensitive collodion and exposing it to light while it is wet

APPENDIX B:
ADDITIONAL READING IN THE
HISTORY OF PHOTOGRAPHY

Adams, Ansel. *Ansel Adams: An Autobiography*. Boston: Little, Brown, 1985.

_____, Mary Street Alinder, and Andrea Gray Stillman. *Ansel Adams: Letters & Images, 1916-1984*. Boston: Little, Brown, 1988.

_____. *The American Image: Photographs from the National Archives, 1860-1960*. New York: Random House, 1979.

Auer, Michel. *The Illustrated History of the Camera*. Boston: New York Graphic Society, 1975.

Braive, Michel. *The Photograph: A Social History*. New York: McGraw-Hill, 1966.

Capa, Robert, Cornell Capa, and Richard Whelan. *Robert Capa: Photographs*. New York: Alfred A. Knopf, 1985.

Cartier-Bresson, Henri. *Henri Cartier-Bresson*. New York: Aperture, 1987.

Coe, Brian. *The Birth of Photography: The Story of the Formative Years, 1800-1900*. London: Ash & Grant, 1976.

_____. *George Eastman & the Early Photographers*. London: Priory Press, 1973.

_____. *Colour Photography: The First Hundred Years, 1840-1940*. London: Ash & Grant, 1978.

_____ and Paul Gates. *The Snapshot Photograph: The Rise of Popular Photography, 1888-1939*. London: Ash & Grant, 1977.

Davis, Barbara. *Edward S. Curtis*. San Francisco: Chronicle Books, 1985.

Dorothea Lange. New York: Aperture, 1981.

Doty, Robert. *Photo Secession: Photography as a Fine Art*. Rochester, N.Y.: The George Eastman House, 1960.

Eisenstaedt, Alfred and Arthur A. Goldsmith. *The Eye of Eisenstaedt*. New York: Viking Press, 1969.

Evans, Harold. *Pictures on a Page*. Belmont, Calif.: Wadsworth, 1978.

Ford, Colin and Karl Steinorth. *You Press the Button, We Do the Rest: The Birth of the Snapshot.* London: Dick Nishen Publishing, 1988.

Galassi, Peter. *Henri Cartier-Bresson, the Early Work.* Museum of Modern Art/New York Graphic Society, 1987.

Gassan, Arnold. *A Chronology of Photography.* Athens, Oh.: Handbook Co., 1972.

Gernsheim, Helmut. *The History of Photography.* New York: McGraw-Hill, 1970.

_____. *The Rise of Photography: The Age of Collodion.* London: Thames & Hodson, 1988.

_____ and Alison Gernsheim. *A Concise History of Photography.* New York: Grosset and Dunlap, 1965.

Gilbert, George. *Collecting Photographica: The Images and Equipment of the First Hundred Years of Photography.* New York: Elsevier-Dutton, 1976.

Grosvenor, Gilbert. *The National Geographic Society and Its Magazine.* Washington, D.C.: National Geographic Society, 1957.

Hamlin, Dora Jane. *That Was the Life.* New York: Norton, 1977.

Henri Cartier-Bresson. New York: Aperture, 1976.

International Museum of Photography and Robert Sobieszek. *Masterpieces of Photography from the George Eastman House.* New York: Abbeville Press, 1985.

Lemagny, Jean-Claude and Andre Rouille, editors. *A History of Photography: Social and Cultural Perspectives.* New York: Cambridge University Press, 1987.

Life: The First 50 Years. Boston: Little, Brown, 1986.

Maloney, John F. *Vintage Cameras and Images: An Identification and Value Guide.* Florence, Ala.: Books Americana, 1981.

Museum of Fine Arts and Doris Bry. *Alfred Stieglitz: Photographer.* Boston: October House, 1965.

Newhall, Beaumont. *The History of Photography,* 5th ed. New York: The Museum of Modern Art, 1982.

_____. *Supreme Instant: The Photography of Edward Weston.* Boston: Little, Brown, 1986.

_____ and Nancy Newhall. *Masters of Photography.* New York: George Braziller, 1958.

Ohrn, Karin Becker. *Dorothea Lange & the Documentary Tradition.* Baton Rouge, La.: Louisiana University Press, 1980.

Pollack, Peter. *The Picture History of Photography.* New York: Harry N. Abrams, 1969. (Abridged edition, 1977.)

Rosenblum, Naomi. *A World History of Photography.* New York: Abbeville Press, 1984.

Sandler, Martin W. *The Story of American Photography: An Illustrated History for Young People.* Boston: Little, Brown, 1977.

Silverman, Jonathan. *For the World to See: The Life of Margaret Bourke-White.* New York: Viking Press, 1983.

Smith, W. Eugene. *W. Eugene Smith: His Photographs and Notes.* New York: Aperture, 1969.

_____ and Ben Maddox. *Let Truth Be the Prejudice: W. Eugene Smith, His Life and Photographs.* New York: Aperture, 1985.

Stryker, Roy and Nancy Wood. *In This Proud Land. America 1935-1943 As Seen in the FSA Photographs.* Greenwich, Conn.: New York Graphic Society, 1973.

Taft, Robert. *Photography and the American Scene: A Social History.* New York: Dover, 1964.

Wade, John. *A Short History of the Camera.* New York: International Publications Service, 1979.

Walker Evans: Photographs for the Farm Security Administration 1935-1938. New York: Da Capo Press, 1973.

Weston, Edward. *The Notebooks of Edward Weston, Vol. I Mexico, Vol. II California.* Millerton, New York: Aperture, Inc., 1961.

_____ and Richard H. Cravens. *Edward Weston.* New York: Aperture, 1988.

Whalen, Richard. *Robert Capa.* New York: Ballentine Books, 1985.

INDEX